The Everyday Cooking Collection

POULTRY
DISHES

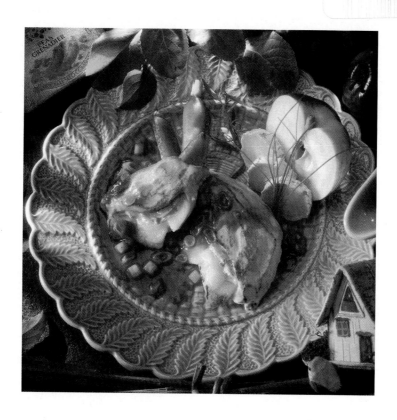

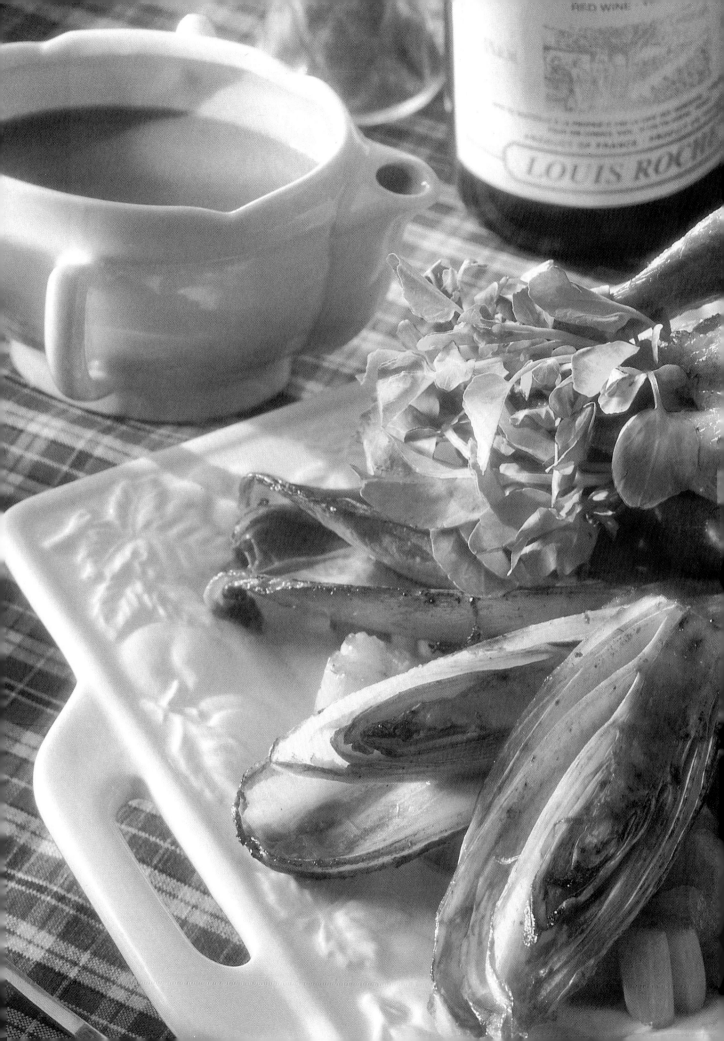

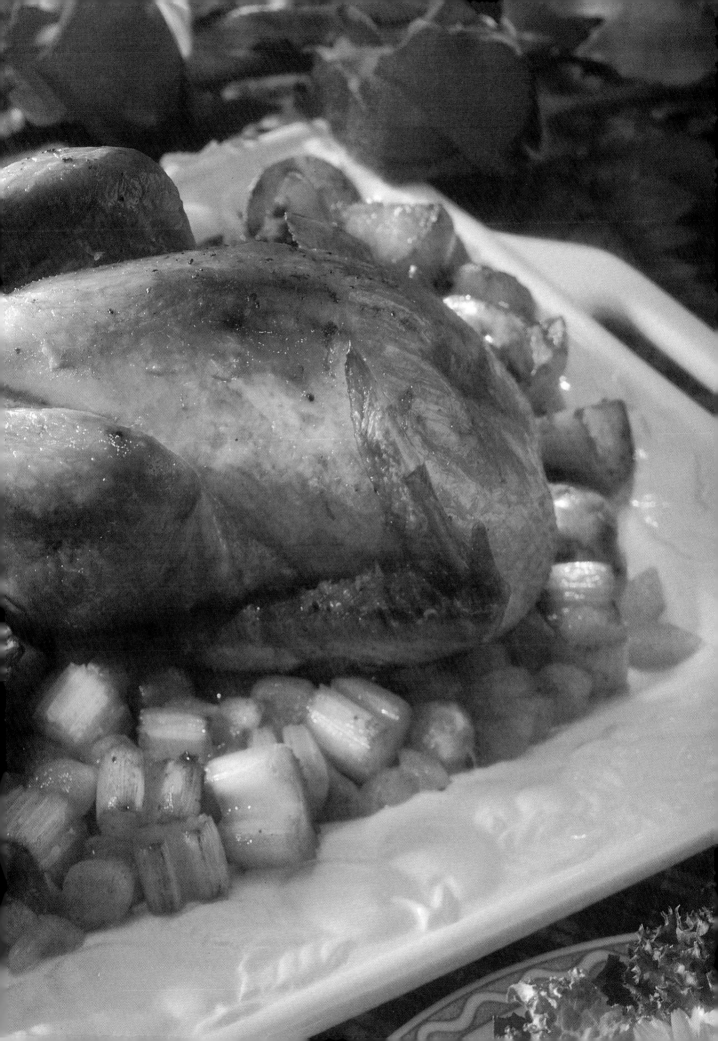

Licensed and produced by:

DIRECT SOURCE
SPECIAL PRODUCTS INC.

©℗1999 DIRECT SOURCE SPECIAL PRODUCTS INC.
Canada: P.O. Box 361,
Victoria Station, Westmount,
Quebec, Canada
H3Z 2V8
U.S.: P.O. Box 2189,
609 New York Road, Plattsburgh,
New York, 12903

Recipes and photos courtesy of:
Les Éditions Multi-Concept Inc.

Printed in Canada

ISBN# 1-896306-51-9

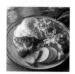

CREAM OF CHICKEN SOUP

4 TO 6 SERVINGS

Preparation Time: 15 minutes
Cooking Time: 25 minutes

2	slices of bread
1 tsp	(5 ml) butter
3/4 cup	(175 ml) coarsely chopped onion
3/4 cup	(175 ml) leeks, sliced (optional)
3/4 cup	(175 ml) sliced celery
1/2 cup	(125 ml) sliced carrots
6 cups	(1.5 L) chicken stock, skimmed of fat
1 cup	(250 ml) potatoes
1	bay leaf
1	sprig of thyme
1	sprig of parsley
	salt and pepper to taste
1 tbsp	(15 ml) cornstarch, diluted in water
20	green grapes
2 tbsp	(25 ml) chopped hazelnuts or walnuts
1/2 cup	(125 ml) 15% cream

Preheat the oven to 350°F (180°C). On a cutting board, cut the bread into cubes. Place them on a cookie sheet and grill in the oven for 10 to 15 minutes; set aside.

In a large pan, melt the butter and sauté the onions, leek, celery and carrots.

Add the chicken stock, potatoes and herbs. Let simmer, covered, for 20 minutes over low heat; season.

With a food processor or an electric mixer, purée the mixture and pour back in the pan. Thicken with cornstarch and add the grapes and nuts.

When serving, add the cream and garnish with croutons.

DUCK HEART SALAD WITH WILD MUSHROOMS

4 SERVINGS

Preparation Time: 15 minutes
Cooking Time: 15 minutes

4 tbsp	(50 ml) olive oil
1 tsp	(5 ml) butter
1 lb	(500 g) duck hearts, cut in half
1 1/2 cups	(375 ml) wild mushrooms (girolle, chanterelle, oyster mushrooms...)
1	shallot, chopped
	salt and pepper, to taste
4 cups	(1 L) mixed greens (radicchio, Boston, curled...)
1 tbsp	(15 ml) sherry vinegar
	ground pepper to taste

In a pan, heat 1 tbsp (15 ml) of oil and melt the butter. Brown the duck hearts for 3 to 4 minutes over high heat. Remove from the stove and set aside.

In another pan, heat 1 tbsp (15 ml) of oil and sauté the mushrooms and shallots; season and set aside.

Garnish the plates with mixed greens, wild mushrooms and duck hearts.

Heat the pan previously used to cook the duck hearts and add 2 tbsp (25 ml) of oil and sherry vinegar. Pour over the salad, season and serve.

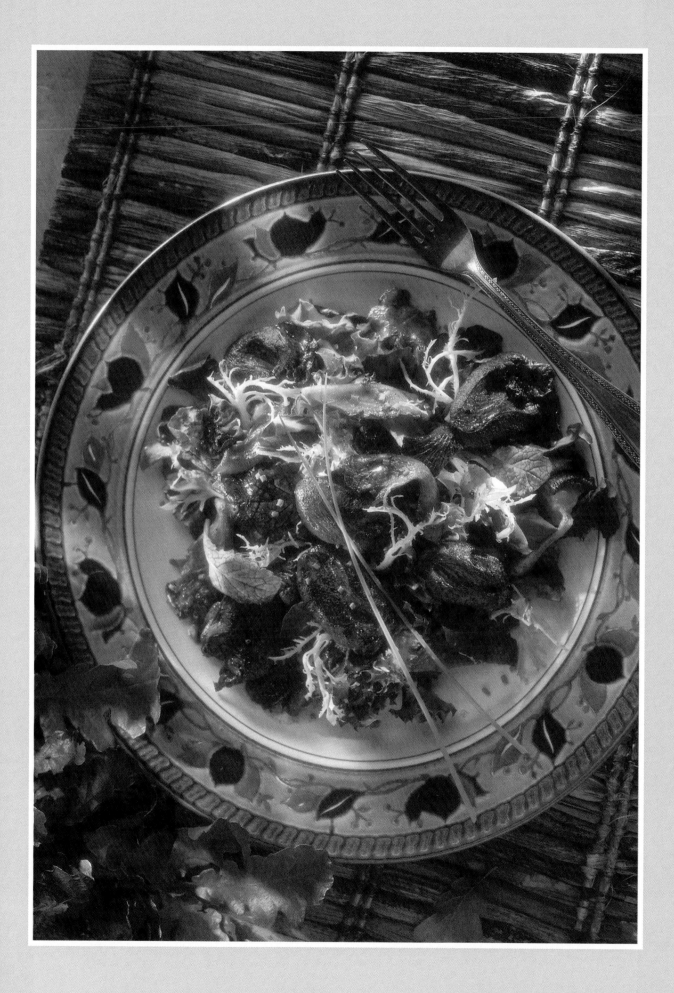

DUCK PASTA SALAD

4 TO 6 SERVINGS

Preparation Time: 15 minutes
Cooking Time: 5 minutes

2 tsp	(10 ml) Dijon Mustard
1/4 cup	(50 ml) olive oil
1 tbsp	(15 ml) fine herb cider vinegar
1 tbsp	(15 ml) lemon juice
	salt and pepper, to taste
6 oz	(180 g) penne pasta, cooked
3/4 cup	(175 ml) carrots, julienned, and lightly blanched
3/4 cup	(175 ml) leek julienned and lightly blanched
6 oz	(180 g) dried duck, sliced
1 tbsp	(15 ml) chopped chives
1 tbsp	(15 ml) chopped fresh parsley
2	endives
2	tomatoes, seeded and diced
1/2 cup	(125 ml) pine nuts or walnuts, lightly grilled
3/4 cup	(175 ml) grated mozzarella or Parmesan cheese,
8	green or black olives

In a large bowl, mix together, the Dijon mustard, olive oil, cider vinegar and lemon juice; season.

Add the pasta, carrots, leeks, dried duck, chives and parsley. Mix well.

Line four plates with endive leaves and place the mixture of pasta on top. Garnish with diced tomatoes, pine nuts, cheese and olives.

DUCK CONFIT
WITH POTATO PANCAKES

4 SERVINGS

Preparation Time: 15 minutes
Cooking Time: 20 to 30 minutes

4	duck confits
1	large onion, sliced
3	large potatoes, finely grated
1/4 tsp	(1 ml) white pepper
1	pinch of salt
1	pinch of nutmeg
2 tbsp	(25 ml) olive oil

Preheat the oven to 300°F (150°C). Bake the duck confit on a cookie sheet for 20 to 25 minutes.

In a large bowl, mix together the onion, potatoes and seasonings. Form several small pancakes.

Heat the oil in a frying pan and cook the pancakes on each side until golden. Serve the duck with the potato pancakes.

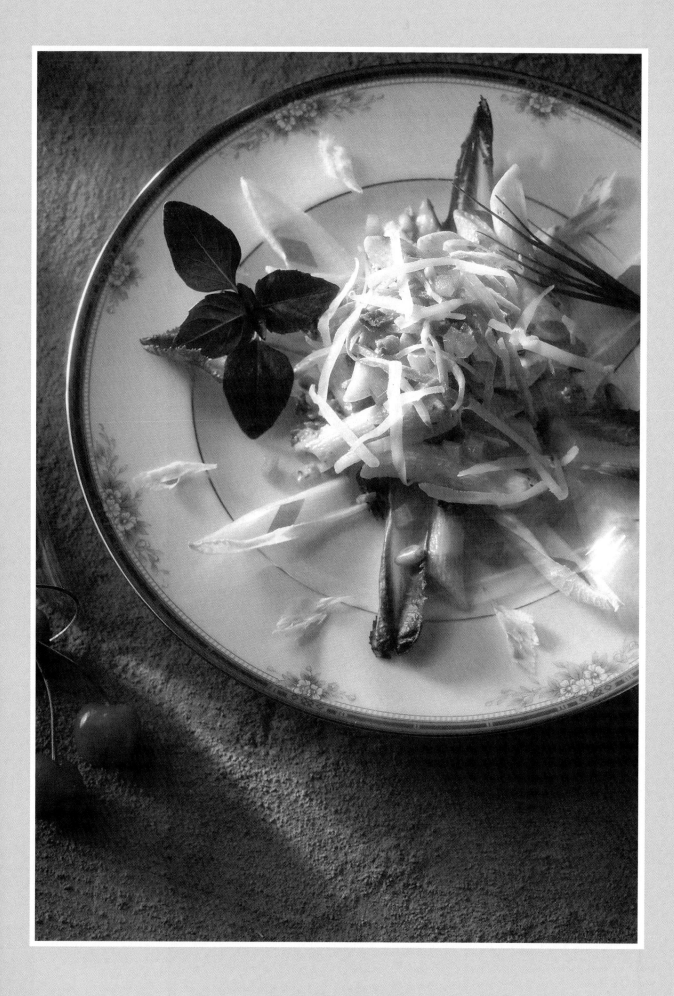

ZESTY CHICKEN WINGS

4 SERVINGS
Preparation Time: 20 minutes
Cooking Time: 15 minutes

12	chicken wings
1 tbsp	(15 ml) butter
1/2 cup	(125 ml) sliced mushrooms
1/2 cup	(125 ml) chopped fresh spinach
2 cups	(500 ml) tomato juice
1 tbsp	(15 ml) white sauce thickener, store bought
1	garlic clove, minced
	pepper to taste
3 cups	(750 ml) rice, cooked (optional)

Preheat the oven to 400°F (200°C). Place the chicken wings on a cookie sheet and bake for approximately 12 minutes.

In a non-stick pan, melt the butter. Sauté the mushrooms over medium-high heat for 2 minutes and add the spinach. Mix well.

Add the tomato juice and slightly reduce. Thicken with the sauce thickener, stirring continuously. Season with garlic and pepper to taste.

Pour the sauce on four plates, and top with the chicken wings. For a main course serve the chicken wings on a bed of rice.

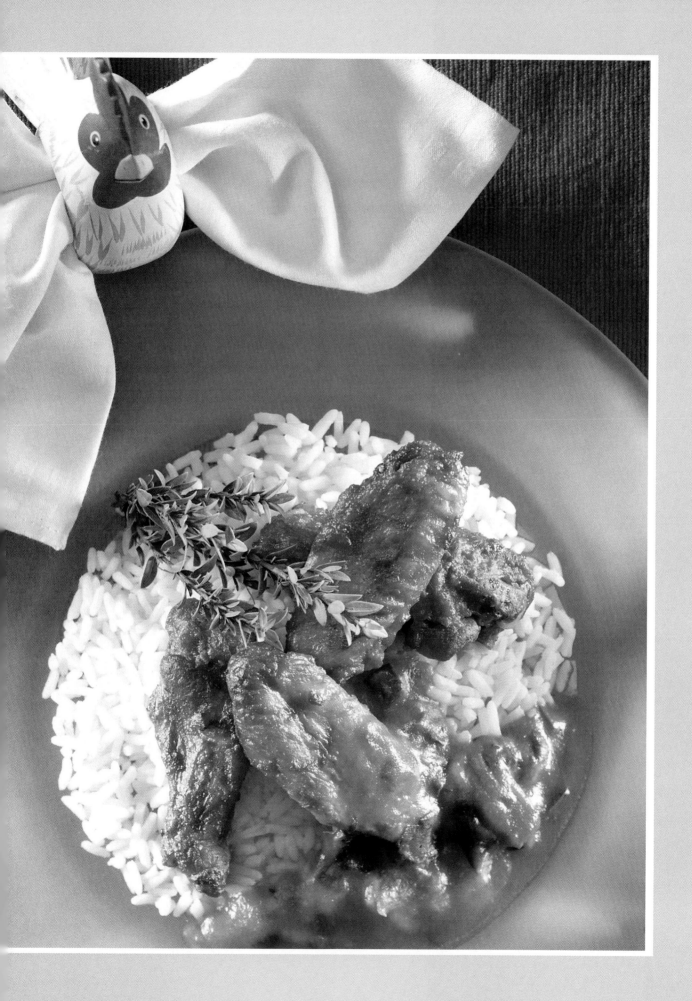

CHICKEN BURGERS

4 SERVINGS

Preparation Time: 10 minutes
Cooking Time: 10 minutes

1 lb	(500 g) ground chicken
1	egg, beaten
2 tbsp	(25 ml) concentrated chicken stock
2 tbsp	(25 ml) fresh parsley, chopped
1/4 cup	(50 ml) onion, chopped
1/4 cup	(50 ml) breadcrumbs
1/2 tsp	(2 ml) ground pepper
4	hamburger buns, toasted
4	lettuce leaves
4	slices of tomato
4	slices of cheese of choice
	mayonnaise, to taste

In a bowl, combine the ground chicken, egg, chicken stock, parsley, onion, breadcrumbs and pepper. Form into four patties.

Grill on the barbecue, for approximately 10 minutes, turning once.

Baste, from time to time, with the chicken broth. Serve on the toasted buns, and garnish with lettuce, tomato, cheese, and mayonnaise.

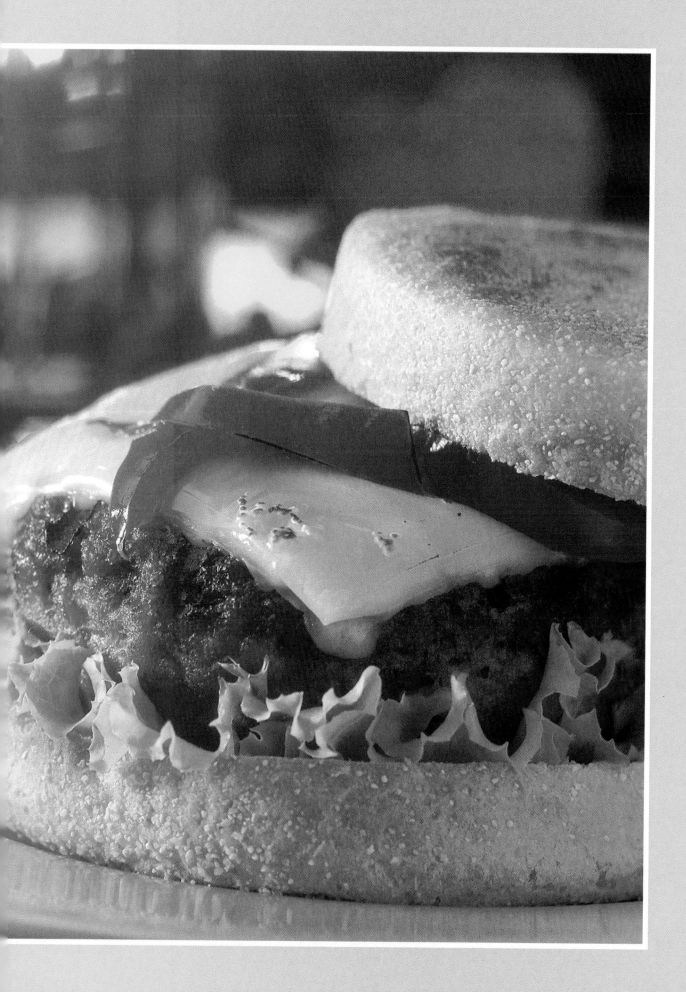

CHICKEN BURGER SURPRISE

4 SERVINGS

Preparation Time: 10 minutes

Cooking Time: 15 minutes

1 lb (500 g) ground chicken
2 tbsp (25 ml) paprika
1 tbsp (15 ml) curry powder
Cayenne pepper, to taste
1/2 tsp (2 ml) dried oregano
1/2 tsp (2 ml) dried thyme
salt and pepper, to taste
1 tbsp (15 ml) butter
4 hamburger buns, toasted
4 slices of cheddar cheese
4 lettuce leaves

In a bowl, mix together the ground chicken, paprika, curry powder, Cayenne pepper, oregano, thyme and seasonings. Shape into four patties and set aside.

In a frying pan, heat the butter and cook the patties for 5 to 7 minutes on each side, depending on their thickness, or barbecue on an oiled grill.

Place the chicken patties on toasted buns, garnish with cheese and lettuce.

TURKEY BREASTS WITH FINE HERBS

4 SERVINGS

Preparation Time: 10 minutes

Cooking Time: 15 minutes

4 6 oz (180 g) turkey breasts
fine herb marinade, of choice
1/2 cup (125 ml) concentrated
chicken stock

Marinate the turkey breasts in the fine herb marinade for a few hours in the refrigerator.

Cook the breasts on a grill over medium heat for 15 minutes. Baste with chicken stock while cooking. Serve.

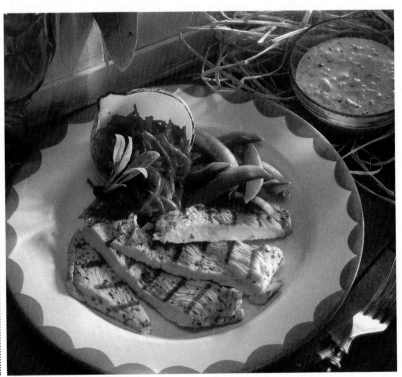

FROM THE GRILL

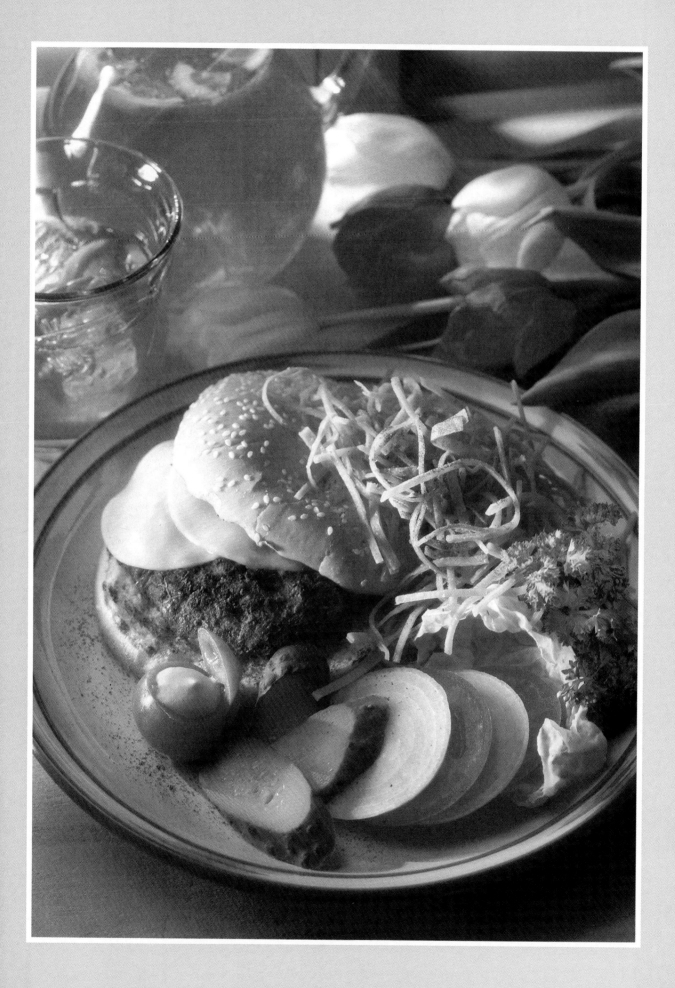

TURKEY SAUSAGES WITH EXOTIC FRUITS

4 SERVINGS

Preparation Time: 20 minutes

Cooking Time: 15 minutes

1 1/2 lb	(750 g) turkey sausage
	lemon and ginger marinade, store bought
3	kiwis, peeled and cut into cubes
1 cup	(250 ml) pineapples cut into cubes
1 cup	(250 ml) papaya cut into cubes
2 tbsp	(25 ml) soft butter
2 tbsp	(25 ml) granulated sugar or brown sugar
1/4 cup	(50 ml) unsweetened orange juice
2 tbsp	(25 ml) orange, grapefruit and lemon zests
1	package of white wine sauce, store bought

Marinate the sausages in the lemon and ginger marinade for a few hours in the refrigerator.

Cook the sausages on the grill over medium heat for 15 minutes.

In a pan, brown the fruit for 5 minutes in the butter and sugar. Add the orange juice and zests; reduce. Add the white wine sauce; simmer for a few minutes.

Serve the sausages covered with the sauce.

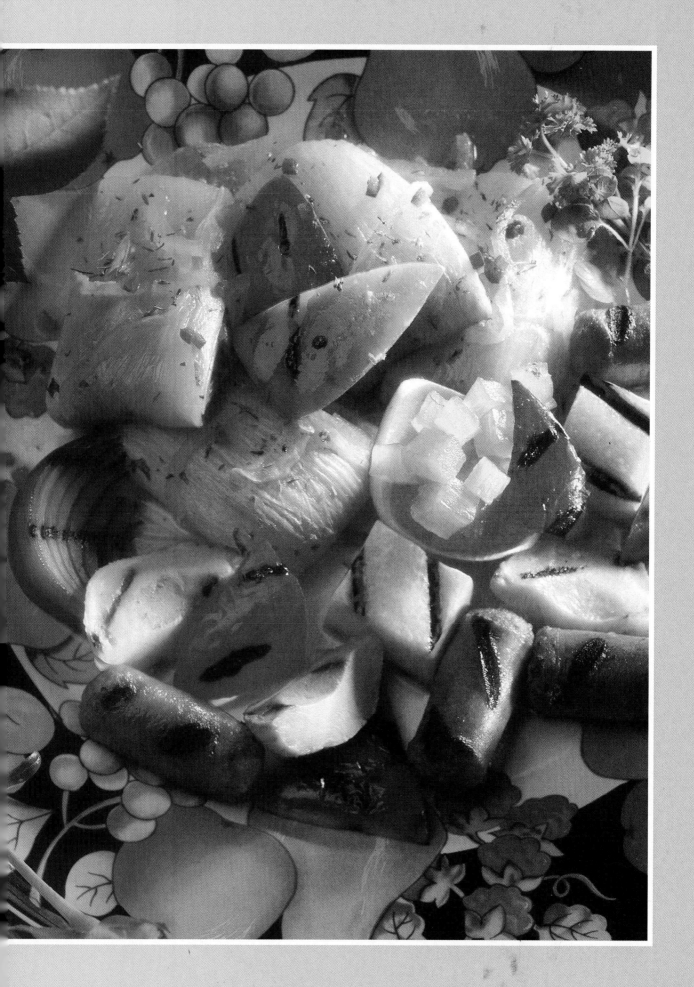

GRILLED CHICKEN BROCHETTES

4 TO 6 SERVINGS
Preparation Time: 15 minutes
Cooking Time: 15 minutes

1/4 cup	(50 ml) dry white wine
2 tbsp	(25 ml) Worcestershire sauce
1 tsp	(5 ml) dried thyme
1	garlic clove, minced
1/4 cup	(50 ml) chicken stock, skimmed of fat
1 lb	(500 g) chicken legs or breasts, cut in cubes
12	mushrooms
12	cubes of pineapple
	ground pepper, to taste

In a bowl combine the white wine, Worcestershire sauce, thyme, garlic and the chicken stock.

Add the chicken cubes, mushrooms and pineapple to the marinade; season with the pepper. Cover and let marinate in the refrigerator for at least 2 hours.

Thread the skewers, alternating the chicken, mushrooms and pineapples. Grill on the barbecue for 10 to 12 minutes, brushing with the marinade while cooking. Serve on a bed of rice.

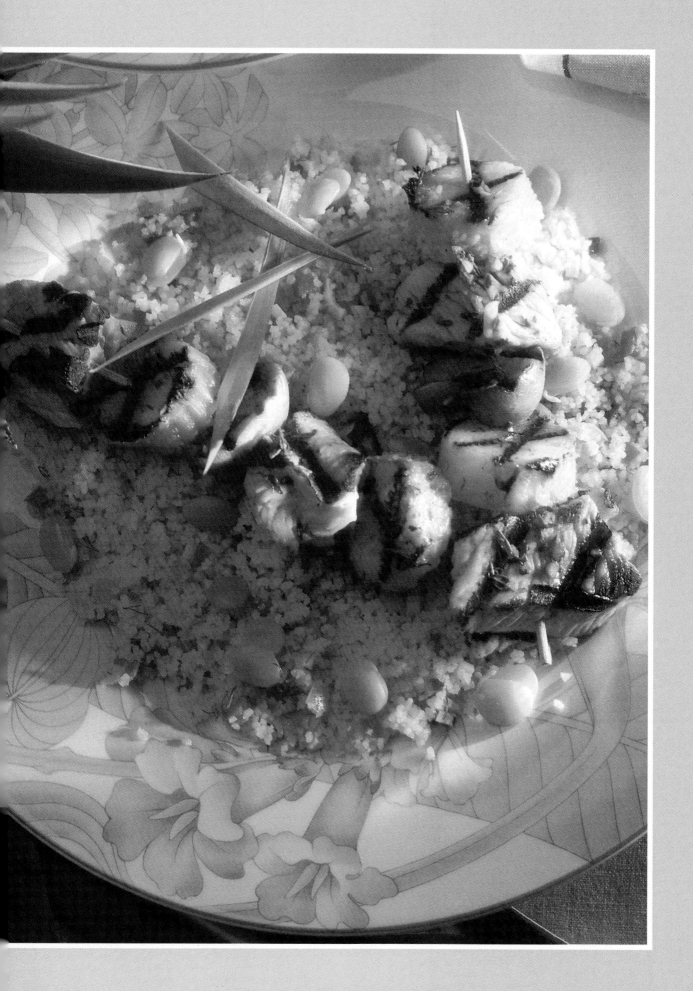

HONEY AND GARLIC CHICKEN BROCHETTES

4 SERVINGS
Preparation Time: 15 minutes
Cooking Time: 10 minutes

1 3/4 cups	(400 ml) Mediterranean marinade, store bought
16	cubes of chicken
1	pepper cut into 16 pieces
16	pineapple cubes
2	apples, cored, and cut into 8 pieces each
1 cup	(250 ml) honey and garlic barbecue sauce, store bought

In a bowl, pour the marinade over the chicken and let marinate in the refrigerator for 1 to 2 hours.

Thread the skewers, alternating the chicken, pepper, pineapple and apple. Cook on the grill for 8 to 10 minutes, turning regularly. Baste with the marinade while cooking.

Serve the brochettes with the honey and garlic barbecue sauce.

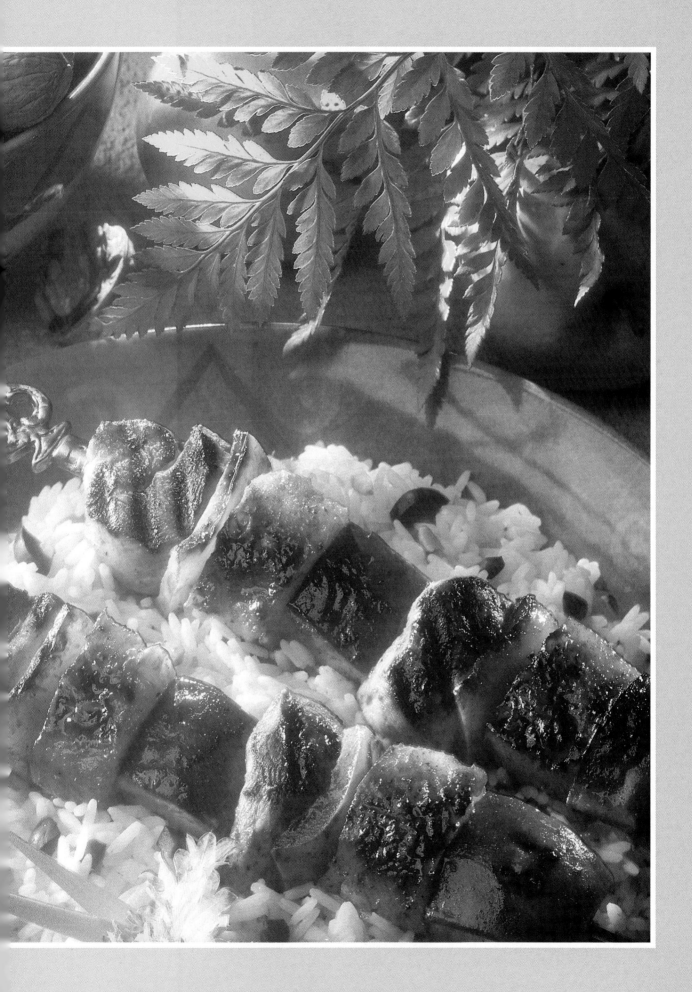

CHICKEN BREASTS WITH LIME

4 SERVINGS

Preparation Time: 5 minutes
Cooking Time: 12 minutes

1 3/4 cups (400 ml) Mediterranean marinade, store bought
1 1/2 lb (750 g) boneless chicken breasts
1 green onion, sliced

In a large bowl, pour the marinade over the chicken breasts. Add the green onion and let marinate for 1 to 2 hours in the refrigerator.

Grill on the barbecue for 5 to 6 minutes on each side, depending on the thickness of the breasts. Baste with the marinade while cooking.

Accompany with sliced potatoes, grilled in aluminum foil.

CHICKEN BREASTS STUFFED WITH HAM AND CHEESE

4 SERVINGS

Preparation Time: 15 minutes
Cooking Time: 5 minutes

4 chicken breasts, boneless and skinless
salt and pepper, to taste
1 tbsp (15 ml) finely chopped fresh ginger
4 slices of ham
4 slices of Gruyère cheese
vegetable oil (in sufficient quantity)
1 lemon, sliced

With a knife, slice the chicken breasts to form pockets.

Season and perfume with ginger. Stuff each breast with a slice of ham and cheese. Close and secure with a toothpick.

Brush the chicken with oil. Place on the barbecue and grill for 5 to 6 minutes on each side.

Remove the toothpicks and serve garnished with slices of lemon.

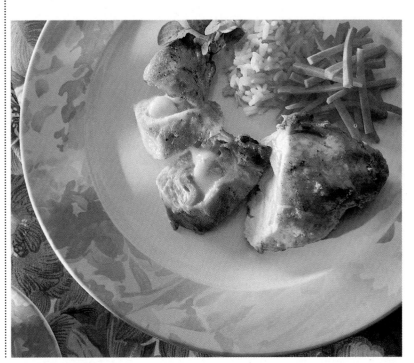

FROM THE GRILL

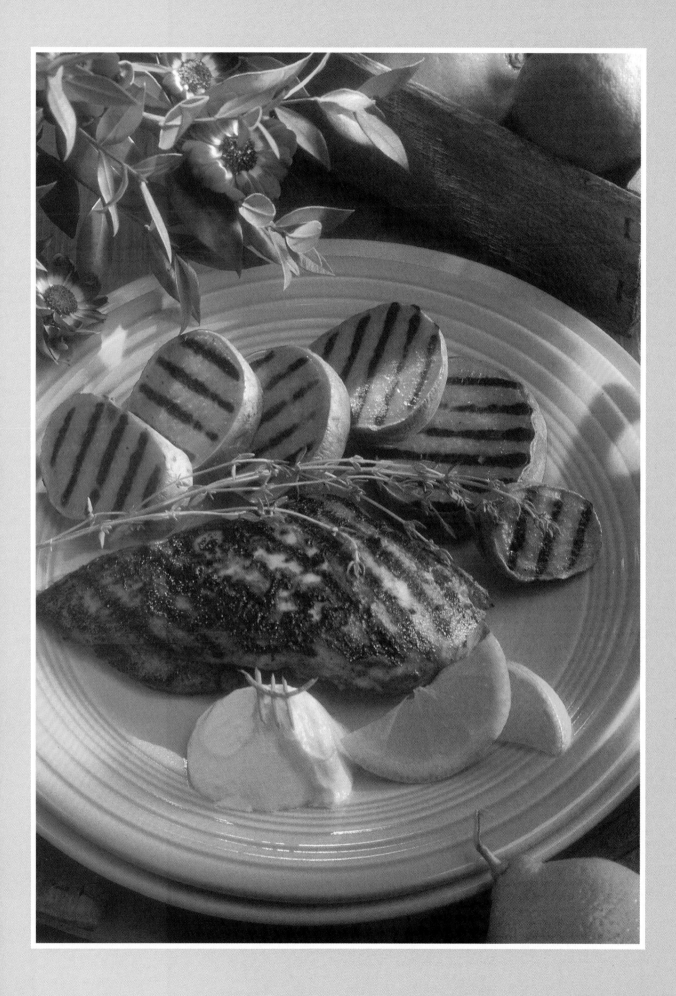

CHICKEN LEG BROCHETTES WITH BEER SAUCE

4 SERVINGS
Preparation Time: 15 minutes
Cooking Time: 25 minutes

MARINADE
- **12 oz** (341 ml) beer
- **2 tbsp** (25 ml) olive oil
- **1/4 cup** (50 ml) unsweetened orange juice
- **2 tbsp** (25 ml) honey
- **2 tbsp** (25 ml) molasses
- **2 tbsp** (25 ml) tamari sauce
- hot sauce, to taste
- zest of 2 oranges
- **1 1/2 lb** (750 g) chicken legs, deboned and cut in two

BEER SAUCE
- **1 tbsp** (15 ml) olive oil
- **2 tbsp** (25 ml) chopped shallots
- **1 tbsp** (15 ml) honey
- **1 tsp** (5 ml) wine vinegar
- **12 oz** (341 ml) beer
- **1 cup** (250 ml) browning sauce, store bought

MARINADE

In a bowl, mix together the beer, olive oil, orange juice, honey, molasses, tamari sauce, hot sauce and orange zest. Add the chicken legs and let marinate in the refrigerator for 1 to 2 hours.

BEER SAUCE

In a saucepan, heat the olive oil and sauté the shallots. Add the honey wine vinegar, beer; reduce by one half. Add the browning sauce and continue cooking for 5 minutes; keep warm.

Thread the chicken on wood skewers (previously soaked in water) and grill on the barbecue over high heat for 12 to 15 minutes or to desired taste (or cook in a pan). Accompany with the beer sauce and steamed rice.

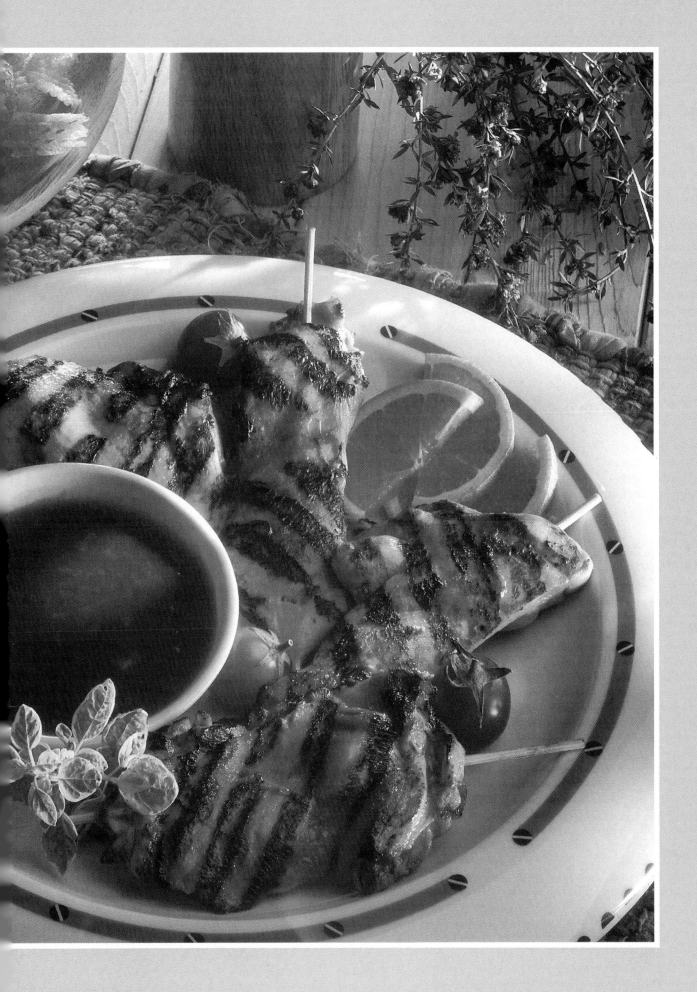

GRILLED CHICKEN BREAST WITH RED BERRIES

4 SERVINGS
Preparation Time: 20 minutes
Cooking Time: 15 to 20 minutes

4	5 to 6 oz (150 to 180 g) chicken breasts
1 tbsp	(15 ml) vegetable oil
	salt and pepper, to taste
1/3 cup	(75 ml) white wine
2 cups	(500 ml) raspberries or strawberries
1 cup	(250 ml) sugar
2 cups	(500 ml) chicken stock, skimmed of fat
	salt and pepper, to taste
1 tbsp	(15 ml) cornstarch
1 tbsp	(15 ml) butter (optional)
2 tbsp	(25 ml) cream (optional)

Brush the chicken breasts with vegetable oil; season and let drain.

In a pan, grill the chicken on both sides and set aside.

Pour the wine into the pan. Add the berries and cook for 5 minutes over low heat.

Add the sugar and simmer for 2 minutes. Add the chicken stock, salt, and pepper and continue cooking for 15 minutes over medium heat.

Thicken with cornstarch, diluted in a little water.

Strain the sauce to remove the berry pits. You can add a little butter and warmed cream.

Pour the sauce onto the plates and place the chicken on top.

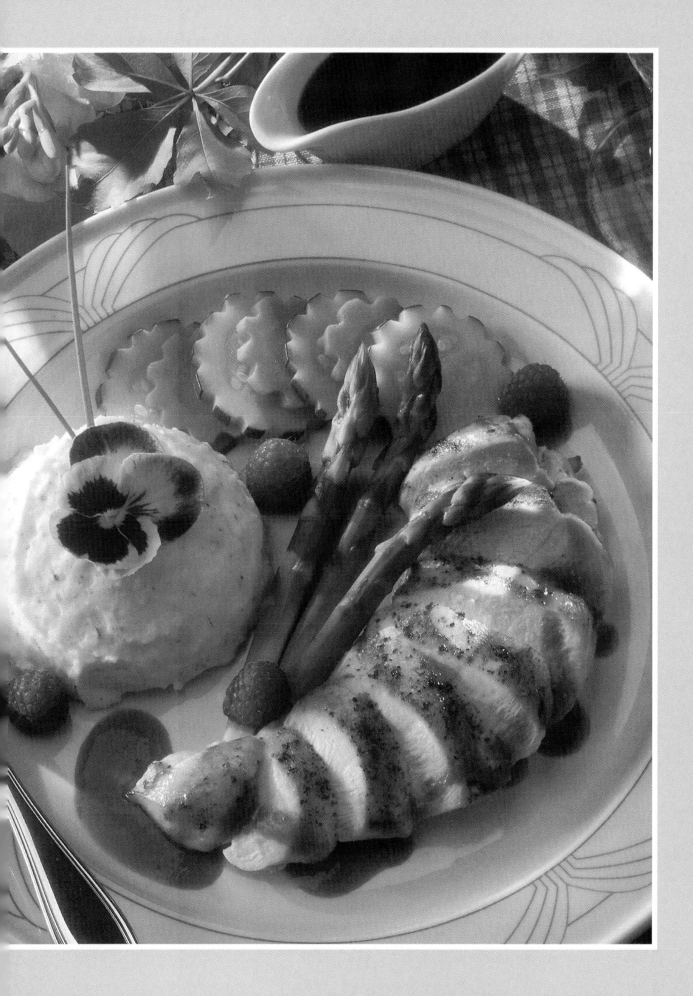

DUCK LEG CONFIT WITH ONION PURÉE

4 SERVINGS

Preparation Time: 10 minutes
Cooking Time: 30 minutes

4 duck leg confits

ONION PURÉE WITH WILD FRUIT
- **1 tbsp** (15 ml) olive oil
- **1 tbsp** (15 ml) butter
- **2 cups** (500 ml) onions, sliced in half rings
- **1 tsp** (5 ml) red or white wine vinegar
- **1/2 cup** (125 ml) maple syrup
- **1/2 cup** (125 ml) wild fruit jam

ONION PURÉE WITH WILD FRUIT

In a pan, heat the oil and butter; add the onions and sauté until golden. Add the vinegar, maple syrup and the wild fruit jam; let simmer over medium heat until dry. Remove from the heat and let cool.

DUCK

Grill the duck legs on the barbecue over medium heat for 15 to 18 minutes. Serve with the onion purée and a green bean salad.

DUCK BREASTS WITH CRANBERRIES

4 SERVINGS

Preparation Time: 15 minutes
Cooking Time: 25 minutes

- **6 oz** (180 g) frozen cranberries
- **1/2 cup** (125 ml) orange juice
- **1 tbsp** (15 ml) honey
- **1/2 cup** (125 ml) honey wine (available in specialty stores)
- **1 tbsp** (5 ml) butter
- **1 tbsp** (5 ml) olive oil
- **4** duck breasts
 salt and pepper, to taste
- **2 tbsp** (25 ml) chopped shallots
- **1** bay leaf
- **1** sprig of thyme
- **1** sprig of parsley
- **1 cup** (250 ml) honey wine
- **1 cup** (250 ml) semi-glaze (brown sauce, store bought)
 orange zest

In a small pan, bring the cranberries, orange juice, honey and honey wine to a boil. Continue cooking for 3 to 4 minutes.

Keep 1/4 cup (50 ml) of cranberries for garnish and reduce the rest to a purée in a food processor.

Preheat the oven to 350°F (180°C).

In a pan, heat the butter and oil. Cook the duck for 1 to 2 minutes on each side; season. Place on a buttered pan and bake for 10 to 12 minutes. Add the shallots and spices to the frying pan and sauté lightly. Add the honey wine. Add the cranberry purée and brown sauce. Simmer for 5 to 10 minutes over low heat.

Line the plates with sauce and cover with slices of duck. Garnish with cranberries and orange zest.

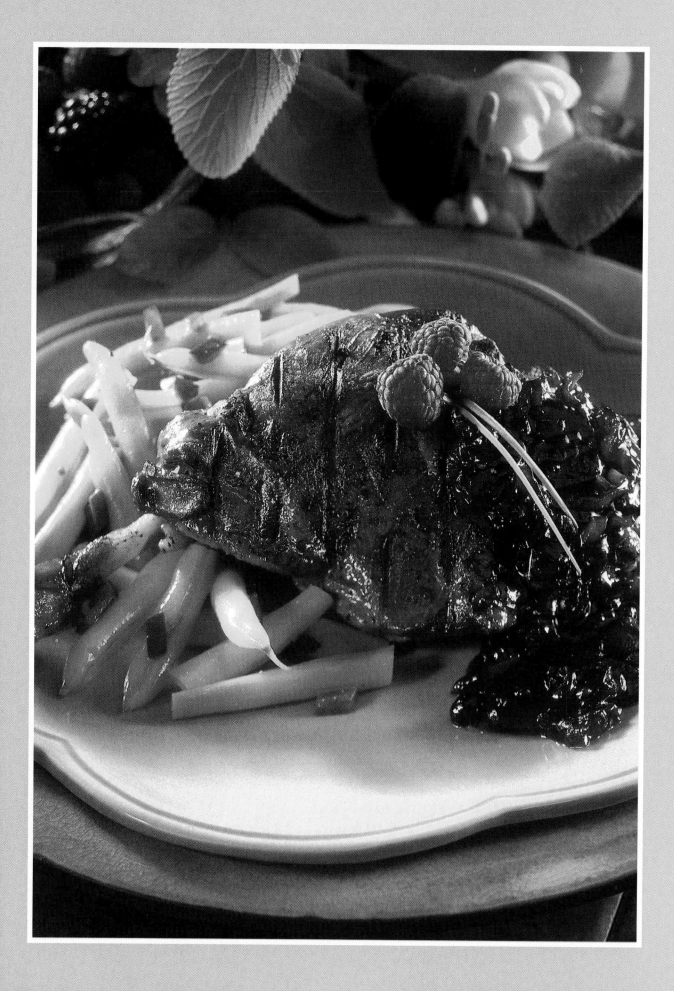

DUCK À L'ORANGE

4 SERVINGS

Preparation Time: 20 minutes

Cooking Time: 1 hour and 30 minutes

1	duck
	salt and pepper, to taste
1 cup	(250 ml) orange marmalade
1/2 cup	(125 ml) orange juice
1/4 cup	(50 ml) water
1/3 cup	(75 ml) dry white wine
1	orange, sliced
	fresh watercress (garnish)

Preheat the oven to 400°F (200°C). Place the duck in a roasting pan. Season well with salt and pepper, and bake for 10 minutes. Reduce the temperature of the oven to 325°F (160°C) and bake for 1 hour.

In a saucepan, mix together the orange marmalade, orange juice, water and white wine. Bring to a boil and remove from the stove.

Remove the duck from the oven and baste the duck with the sauce. Place the orange slices on the duck and bake for 10 minutes. Baste a few more times during cooking.

When ready to serve, place the duck on a platter and garnish with fresh watercress. Accompany with the sauce in a gravy boat.

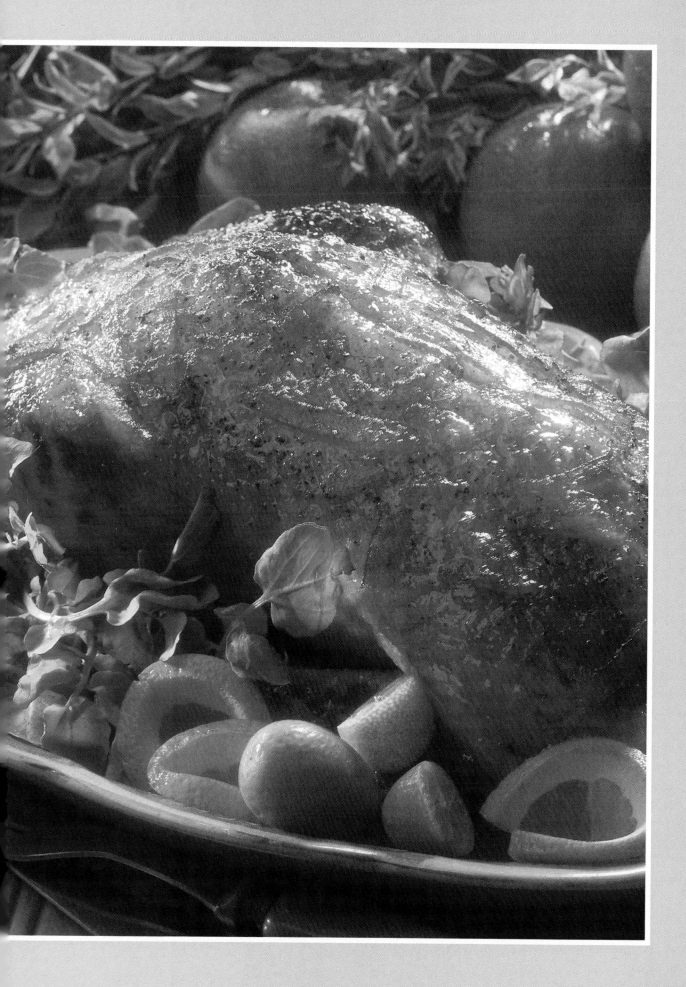

DUCK LEGS WITH FINE HERBS

4 SERVINGS

Preparation Time: 10 minutes

Cooking Time: 1 hour 15 minutes

1 tsp	(10 ml) butter
4	duck legs
	salt and pepper, to taste
2 tbsp	(25 ml) shallots, chopped
	savory, rosemary and thyme, to taste
1 cup	(250 ml) dry white wine or apple juice
1 1/2 cups	(375 ml) chicken broth
1 1/2 cups	(375 ml) water
1 1/2 cups	(375 ml) melted butter
1 tbsp	(15 ml) flour
2 tbsp	(25 ml) fresh parsley, chopped

In a large pan, melt the butter and sauté the duck legs for 2 to 3 minutes on each side. Season. Add the shallots and fine herbs. Brown for 1 to 2 minutes. Add the white wine, chicken broth and water. Cover and simmer for 1 hour over low heat. Thicken the sauce with a mixture of butter and flour. Garnish with parsley and serve.

DUCK BREAST WITH BLACK CURRANT SAUCE

4 SERVINGS

Preparation Time: 20 minutes

Cooking Time: 40 minutes

1 cup	(250 ml) garlic cloves, not peeled
	cold water (in sufficient quantity)
2	medium potatoes
2 cups	(500 ml) milk
2	black currant tea bags
2 cups	(500 ml) boiling water
2	duck breasts (magrets)
2 tbsp	(25 ml) coarse salt
1 tbsp	(15 ml) black, cracked pepper
2 tbsp	(25 ml) black currant vinegar
1/4 cup	(50 ml) black currant jelly or jam

Preheat the oven to 350°F (180°C). In a saucepan, cover the garlic cloves with cold water. Bring to a boil, remove from the stove and let cool. Peel the garlic and place it in a pan with the potatoes and milk. Cook over medium heat for 30 minutes. Mash the garlic and the potatoes to obtain a fine purée. Keep warm.

Steep the black currant tea in 2 cups (500 ml) of boiling water. Brush the duck breasts with coarse salt and cracked black pepper.

Over medium heat, cook the breasts, skin side down, for 2 1/2 minutes, turn them over and cook for another 2 1/2 minutes. Remove from the pan and place in a baking dish. Put the pan back on the stove over medium heat. Add the black currant vinegar and tea. Bring to a boil and let reduce by half. Turn off the burner and add the jelly to thicken the sauce.

Finish baking the breasts in the oven for 5 minutes. Slice the breasts and serve with the garlic and potato purée. Garnish with the black currant sauce.

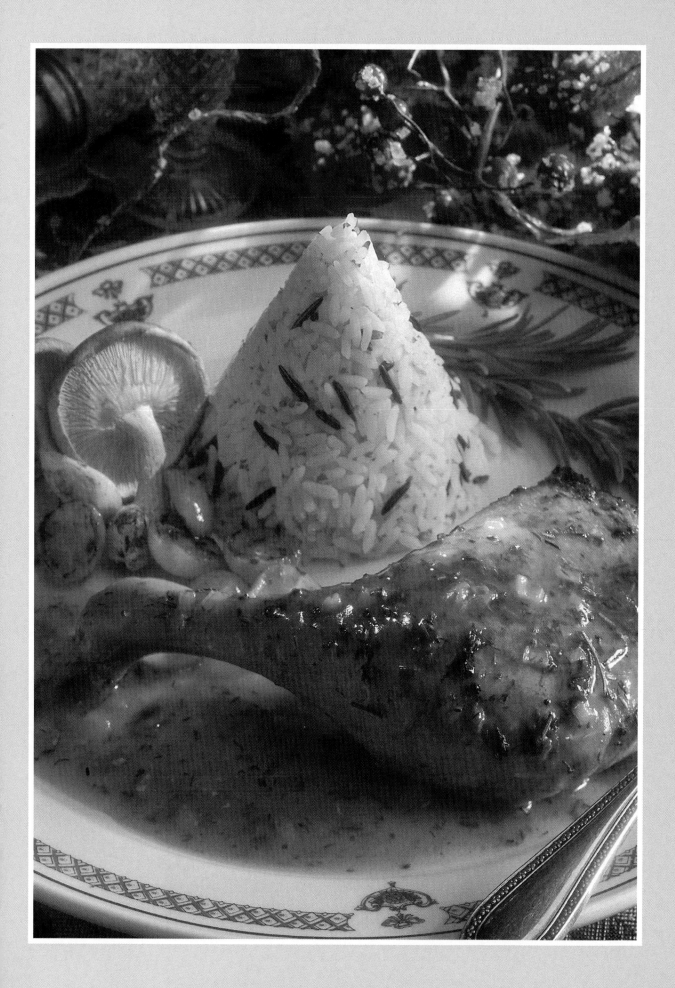

BARBARY DUCK WITH JOYFUL SURROUNDINGS

8 SERVINGS

Preparation Time: 20 minutes
Cooking Time: 3 hours 15 minutes

1	10 lb (5 kg) Barbary duck
2	oranges, quartered
1 tbsp	(15 ml) butter
1 cup	(250 ml) onions chopped
1/2 cup	(125 ml) celery chopped
1/2 cup	(125 ml) carrots, cut in pieces
2 tbsp	(25 ml) butter
2 cups	(500 ml) sliced onions
1/4 cup	(50 ml) chopped walnuts
2	pears, peeled and cut into pieces
1/4 cup	(50 ml) orange marmalade
1/4 cup	(50 ml) honey
1/4 cup	(50 ml) orange liqueur
1 1/2 cups	(375 ml) dry white wine
2 cups	(500 ml) brown sauce, store bought

Preheat the oven to 350°F (180°C). On a cutting board, trim the fat off the duck and stuff the interior with the orange quarters. Keep the giblets and set aside.

Place the duck in a buttered roasting pan and bake for 2 hours.

Add the onions, celery and carrots. Continue cooking for 1 hour.

In a pan, melt 2 tbsp (25 ml) of butter and sauté the onions. When they are golden incorporate the nuts, pears, orange marmalade and honey. Cook over low heat for 5 minutes and keep warm.

Remove the duck from the roasting pan and keep warm. Remove the excess fat from the pan. Add the orange liqueur and white wine. Add the brown sauce and let simmer until the sauce sticks to the back of a wooden spoon.

Cut the duck into thin slices and serve with the onion jam. Cover with the sauce.

DUCK BREASTS WITH CRANBERRY AND APRICOT

4 SERVINGS

Preparation Time: 10 minutes
Cooking Time: 15 minutes

2 tbsp	(10 ml) butter
1 tsp	(5 ml) olive oil
4	duck breast halves
	salt and pepper, to taste
2 tbsp	(25 ml) chopped shallots
3/4 cup	(175 ml) dried apricots, sliced
3/4 cup	(175 ml) dried or frozen cranberries
1/4 cup	(50 ml) sugar
1 tsp	(5 ml) cider vinegar
12 oz	(341 ml) beer
1/2 cup	(125 ml) orange juice
1 cup	(250 ml) brown sauce
	orange and lemon zests
	mint leaves

In a pan, heat the oil and melt the butter. Cook the duck breasts for 3 to 4 minutes on each side, over medium heat, until golden; season. Remove the duck breasts from the pan and keep warm.

Add the shallots, apricots and cranberries; let color lightly. Sprinkle with sugar, mix well and add the vinegar, beer and orange juice. Let reduce by half and add the brown sauce. Simmer until the sauce thickens.

Pour the sauce onto the plates and garnish with the slices of duck breast. Decorate with orange and lemon zests and mint leaves.

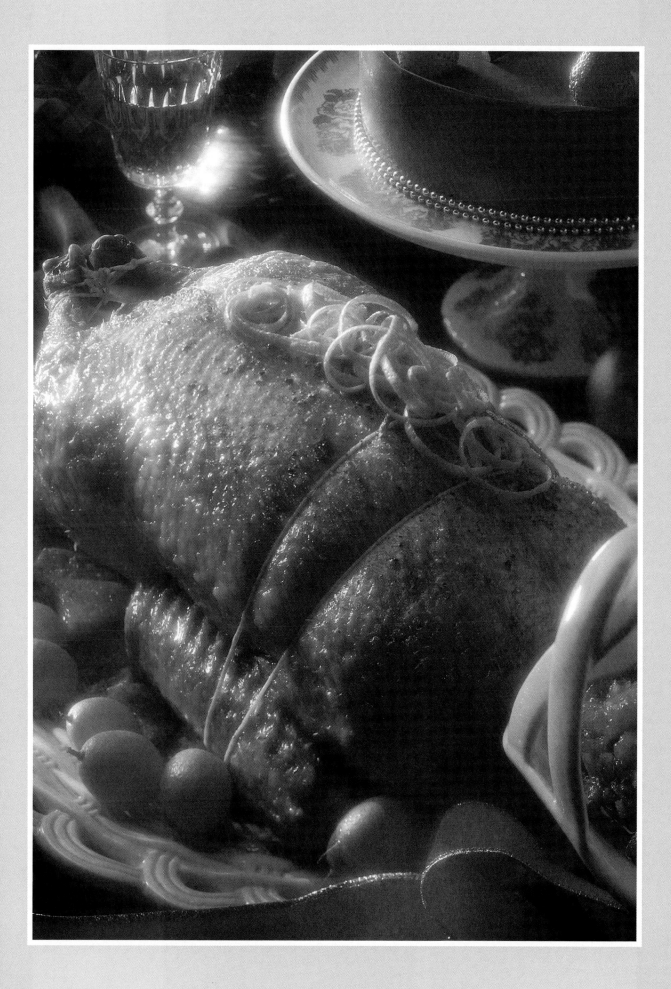

DUCK BREASTS WITH ONION AND CRANBERRY CONFIT

4 SERVINGS

Preparation Time: 30 minutes
Cooking Time: 30 minutes

ONION AND CRANBERRY CONFIT

2 tbsp	(25 ml) butter
2 cups	(500 ml) sliced onions
1 cup	(250 ml) cranberries
1/2 cup	(125 ml) unsweetened apple juice
1/2 cup	(125 ml) maple syrup
1/2 cup	(125 ml) apple jelly
1/2 tsp	(2 ml) raspberry vinegar

PORTO SAUCE

1 tsp	(5 ml) butter
1 tbsp	(15 ml) chopped shallots
1 cup	(250 ml) Port or red wine
1	bay leaf
1	sprig of parsley
1	sprig of thyme
1 1/2 cups	(375 ml) brown sauce, store bought

DUCK BREASTS

2 tsp	(10 ml) butter
2	3/4 lb each (375 g) duck breasts

ONION AND CRANBERRY CONFIT

In a pan, heat the butter and sauté the onions. Add the cranberries, apple juice, maple syrup, apple jelly and raspberry vinegar. Let simmer over medium heat for approximately 12 to 15 minutes; keep warm.

PORTO SAUCE

In a small pan, melt the butter and sauté the shallots. Add the port, bay leaf, parsley and thyme; let reduce by half. Add the brown sauce and let simmer over low heat for 2 to 3 minutes; strain and keep warm.

DUCK BREASTS

In an ovenproof skillet, heat the butter and cook the duck breasts for 2 minutes on each side. Finish cooking in the oven at 350°F (180°C), with the skin side down, for 10 minutes or until the desired taste is reached.

Cut the breasts into thin slices and serve on plates lined with the porto sauce. Garnish with the onion and cranberry confit.

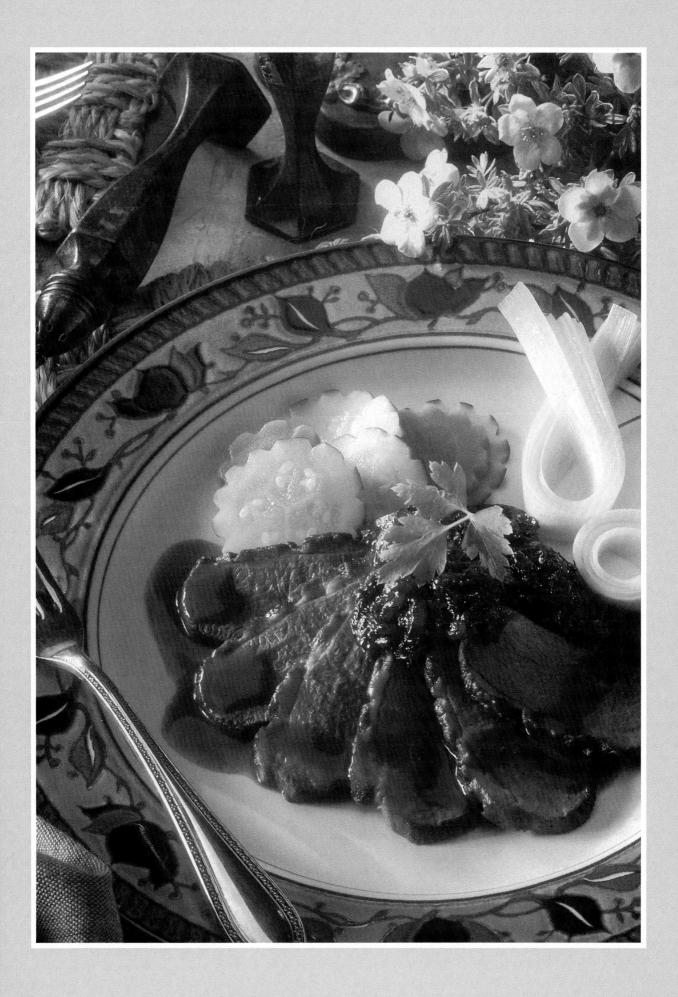

DUCK BREASTS (MAGRETS) WITH BLUEBERRY SAUCE

4 SERVINGS
Preparation Time: 15 minutes
Cooking Time: 20 minutes

2 tbsp	(25 ml) butter
2	onions, sliced
2 tbsp	(25 ml) honey
1/4 cup	(50 ml) blueberry puree or blueberry jelly
1 tbsp	(15 ml) butter
2	duck breasts (magrets)
	salt and pepper, to taste
1 tbsp	(15 ml) butter
1 tbsp	(15 ml) chopped shallots
1/2 cup	(125 ml) Madeira wine
1/2 cup	(125 ml) dry red wine
1 cup	(250 ml) brown sauce, store bought
1/2 cup	(125 ml) blueberries, fresh or frozen

Preheat the oven to 350°F (180°C). In a frying pan, melt the butter and sauté the onions until golden. Add the honey and blueberry purée. Reduce until it becomes jam-like, keep warm.

In another ovenproof skillet, heat the butter and cook the duck breasts, skin side down, for 2 minutes on each side.

Season and bake for approximately 10 minutes, or until your desired taste. Remove the breasts from the oven and keep warm.

In a small pan, melt the butter and sauté the shallots. Deglaze with Madeira wine and red wine. Reduce by half and add the brown sauce. Let simmer for a few minutes and strain. Add the blueberries and keep warm.

Cover the plates with the sauce and fan out the duck slices. Garnish with the onion and blueberry jam.

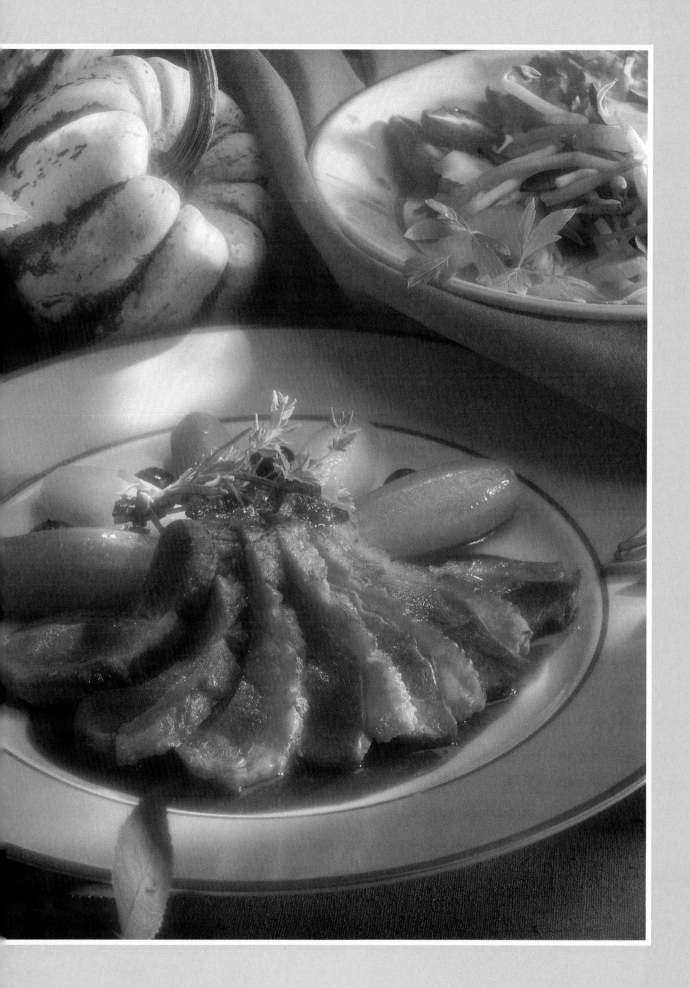

ROASTED PHEASANT WITH WHITE SAUCE

4 SERVINGS
Preparation Time: 10 minutes
Cooking Time: 1 hour

2	pheasants
2 tbsp	(25 ml) melted butter
	salt and pepper, to taste
3/4 cup	(175 ml) small onions
2	stalks of celery, chopped
1	bouquet of spice (1 bay leaf, 1 sprig of thyme, 1 sprig of parsley)
2 cups	(500 ml) white sauce
1/2 cup	(125 ml) 35 % cream
1 cup	(250 ml) brown sauce, store bought
GARNISH	
1 cup	(250 ml) watercress

Preheat the oven to 350°F (180°C). Place the pheasants in a casserole, and brush them with the melted butter; season. Cook in the oven for 30 minutes and add small onions and celery; continue cooking for 15 minutes.

Remove the pheasants, onions, and celery from the casserole; keep warm. Add the bouquet of spices and the white sauce; cook over medium heat and reduce by half.

Add the 35% cream and brown sauce. Let simmer until the sauce is reduced by half.

Strain the sauce and keep warm. Place the pheasants on a serving platter and cover with sauce. Garnish with watercress and serve.

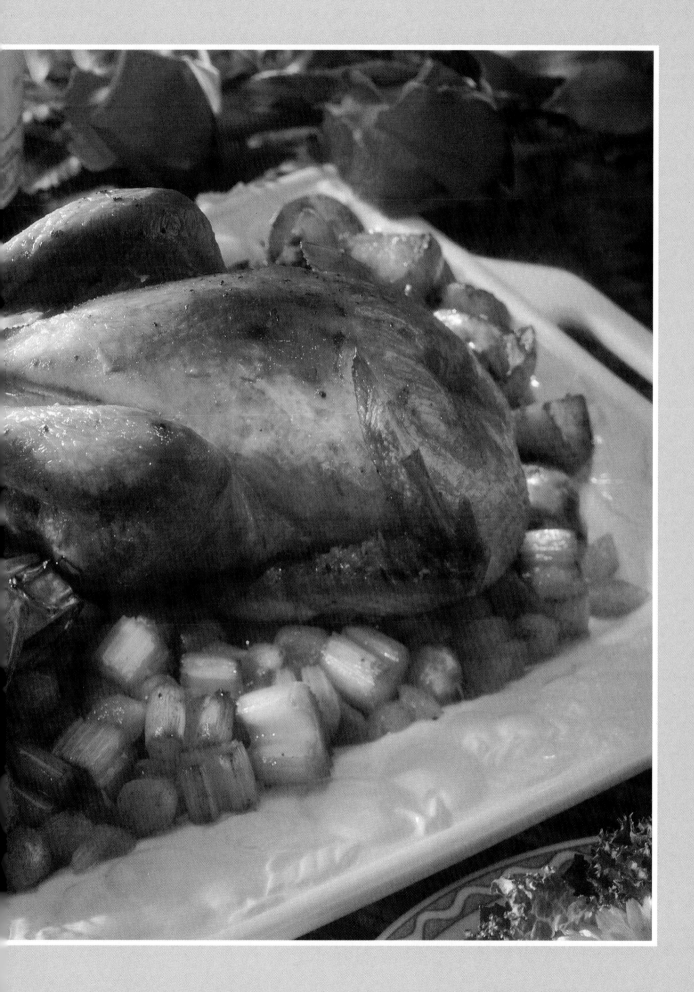

CORNISH HENS

4 SERVINGS

Preparation Time: 20 minutes
Cooking Time: 1 hour

2 tsp	(10 ml) olive oil
1 tsp	(5 ml) butter
2	Cornish hens, cut in two
	salt and pepper, to taste
1	onion, sliced
1 tbsp	(15 ml) chopped shallots
1/2 cup	(125 ml) chopped smoked bacon
1 cup	(250 ml) thinly sliced carrots
1 tsp	(5 ml) minced garlic
2	tomatoes, peeled, seeded and diced
2 cups	(500 ml) beer
1 cup	(250 ml) brown sauce, store bought
1	bay leaf
1	sprig of thyme
1	sprig of parsley
2 cups	(500 ml) sliced mushrooms
1/2 cup	(125 ml) 35% cream

In a casserole or a large pan heat the oil and butter. Cook the Cornish hens until golden; season. Add the onion, shallots, bacon and the carrots. Brown well and add the garlic, tomatoes, beer, brown sauce and spices. Simmer over low heat for 30 to 35 minutes.

Add the mushrooms and the cream. Simmer until the sauce is thick. If necessary, thicken the sauce with a mixture of butter and flour.

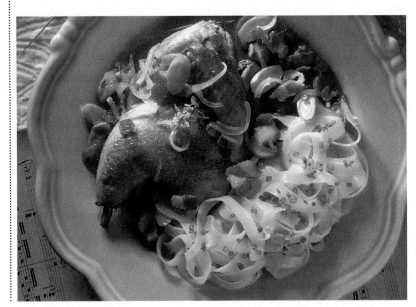

QUEEN OF SPADES CORNISH HEN

4 SERVINGS

Preparation Time: 30 minutes
Cooking Time: 1 hour

4	Cornish hens, or 2 small chickens cut into 2
2 cups	(500 ml) dry red wine
1/2 cup	(125 ml) olive oil
1/2 cup	(125 ml) Soya sauce
1/4 cup	(50 ml) brown sugar
2 tsp	(10 ml) ground ginger
1 tsp	(5 ml) dry oregano
1	garlic clove, minced
1/2 tsp	(2 ml) chili peppers
1 tbsp	(15 ml) cornstarch

Place the Cornish hens in a deep, baking dish. In a bowl, combine the red wine, olive oil, Soya sauce, brown sugar, ginger, oregano, garlic and chili peppers. Pour the marinade over the Cornish hens, cover, and let marinate in the refrigerator for 8 hours, turning a few times.

Preheat the oven to 350°F (180°C). Bake the Cornish hens, uncovered, in the marinade, for 1 hour, basting often.

Remove the Cornish hens from the pan. Cover, and set aside.

Pour the marinade into a small saucepan and let reduce by half over high heat. To thicken the sauce, dilute the cornstarch in a little water and add it to the marinade. Place the Cornish hens on a platter. Cover with the sauce and serve.

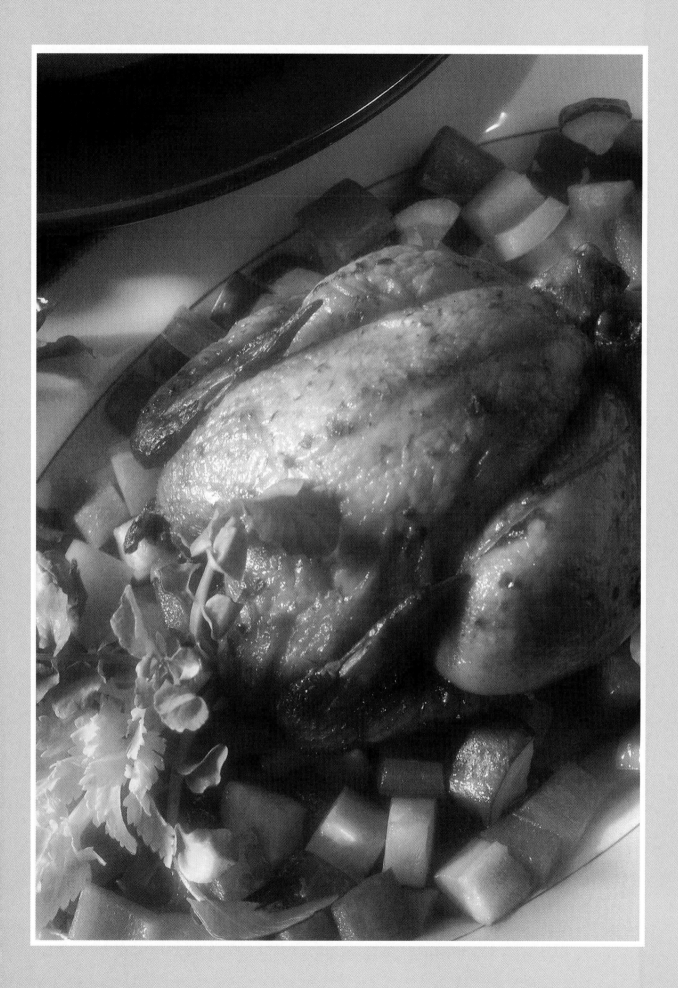

QUAILS WITH PEARS

4 SERVINGS

Preparation Time: 25 minutes

Cooking Time: 30 minutes

8	quails, deboned, keep the legs and wings
	salt and pepper, to taste
1/4 cup	(50 ml) soya sauce
8	pears, peeled and cored
8	slices of bacon
2 tbsp	(25 ml) butter
1	shallot, finely chopped
1/4 cup	(50 ml) regular or white wine vinegar
1/4 cup	(50 ml) dry white wine
2 tbsp	(25 ml) Poire William liqueur
1 cup	(250 ml) chicken stock, skimmed of fat
2 tbsp	(25 ml) brown sauce thickener

Season the interior of the quails with salt and pepper. Place the quails on a plate and pour Soya sauce over them. Cover well and let marinate for 30 minutes at room temperature.

Preheat the oven to 350°F (180°C). In a dutch oven, put the pears in between the quails and tie the legs together. Place the bacon slices on top of the quails. Bake for 15 to 20 minutes. Remove from the oven, cover and set aside.

In a pan, melt the butter over low heat and sauté the shallots for 2 minutes. Add the vinegar and let reduce until almost dry. Incorporate the white wine and the Poire William liqueur, and reduce by half. Add the chicken stock and let simmer for 8 minutes. Add the sauce thickener.

When serving, pour the sauce around the quails. Garnish with vegetables of your choice and rice.

STUFFED QUAILS WITH THYME SAUCE

4 SERVINGS

Preparation Time: 25 minutes

Cooking Time: 20 minutes

4	6 oz (150 g) quails, deboned

STUFFING

4 oz	(10 g) chicken meat
1	drop of white wine
1	egg white, medium
2 tbsp	(25 ml) 35% cream
2 oz	(60 g) wild rice, cooked
1 1/2 oz	(45 g) foie gras, cut into small cubes
	salt and pepper, to taste
2 tbsp	(25 ml) melted butter

THYME SAUCE

1/2 cup	(125 ml) white wine
6	sprigs of fresh thyme
1 cup	(250 ml) chicken broth, skimmed
1 tbsp	(15 ml) butter
1/4 cup	(50 ml) 35% cream

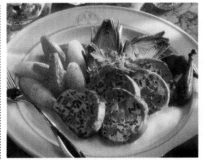

STUFFING

In a food processor, mince the chicken. Add the white wine, egg white and cream. Mix until smooth.

Gently mixing with a spatula, add the wild rice and the foie gras. Mix well and season with salt and pepper.

Stuff the quails and brush lightly with melted butter. Place in a casserole and bake at 350°F (180°C) for 20 minutes.

THYME SAUCE

In a pan, combine the white wine and fresh thyme and reduce by half. Add the chicken broth and reduce again. Lightly thicken with butter. Cook a few minutes over medium heat and add the cream.

Serve the quail on plate garnished with sauce.

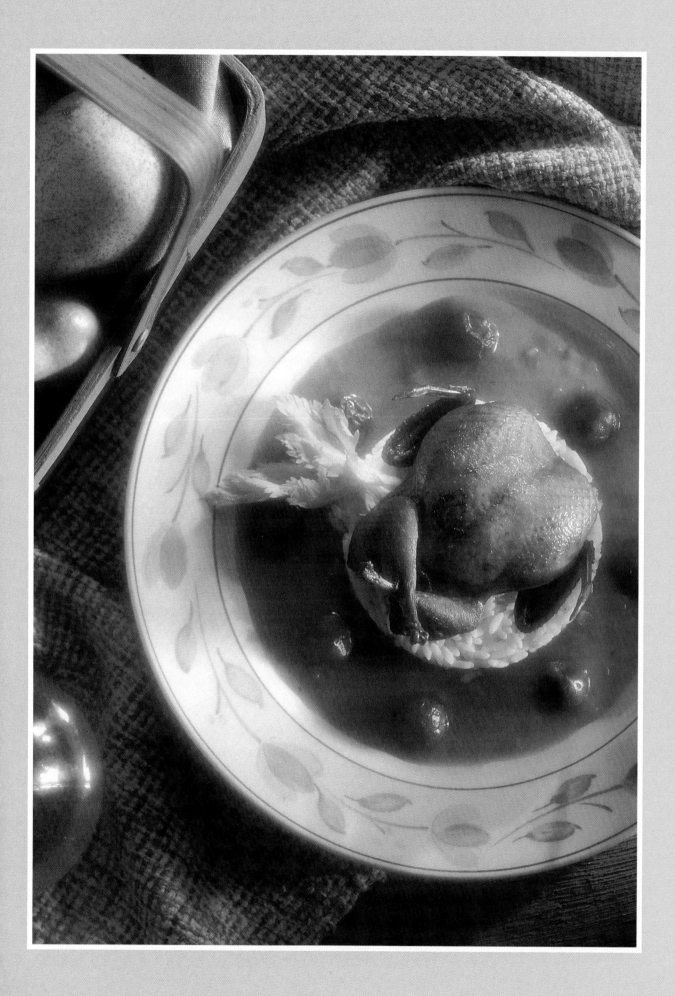

QUAILS WITH GLAZED GRAPES

4 SERVINGS

Preparation Time: 20 minutes

Cooking Time: 20 minutes

8	quails
	pepper, to taste
	dry savory, to taste
3 tbsp	(50 ml) olive oil
2 tbsp	(25 ml) fruit vinegar
3	sprigs of thyme
5	juniper berries
1/2	carrot, cut in rounds
1/2	onion, cut in rounds

SAUCE

2 tbsp	(25 ml) butter
1 to 2	shallots, finely chopped
6	oyster mushrooms
1/4 cup	(50 ml) dry white vermouth
1 cup	(250 ml) browning sauce, store bought or chicken stock
	salt and pepper, to taste
20	green grapes, peeled or not
1 tbsp	(15 ml) liquid honey
	chopped, fresh parsley

Pepper the quails and brush with savory; set aside.

In a deep dish, add the oil, fruit vinegar, thyme, juniper berries, carrot and onion.

Place the quails in the dish, cover and marinate in the refrigerator for 2 to 3 hours, taking care to turn from time to time.

Preheat the oven to 425°F (220°C). Remove the quails from the marinade, and place them in a roasting pan. Remove the sprigs of thyme, and the juniper berries from the marinade and set aside. Place the pan in the middle of the oven, reduce the heat of the oven to 350°F (180°C) and cook for 12 to 15 minutes.

SAUCE

In a pan, melt the butter over high heat and sauté the shallots and oyster mushrooms. Add the vermouth and reduce until the liquid evaporates.

Incorporate the brown sauce or stock, season to taste. Add the thyme and juniper berries from the marinade. Let simmer for 2 to 3 minutes.

In another pan or in a microwave, heat the honey and glaze the green grapes.

Place the quails on a serving platter. Cover with sauce; garnish with grapes and sprinkle with fresh parsley.

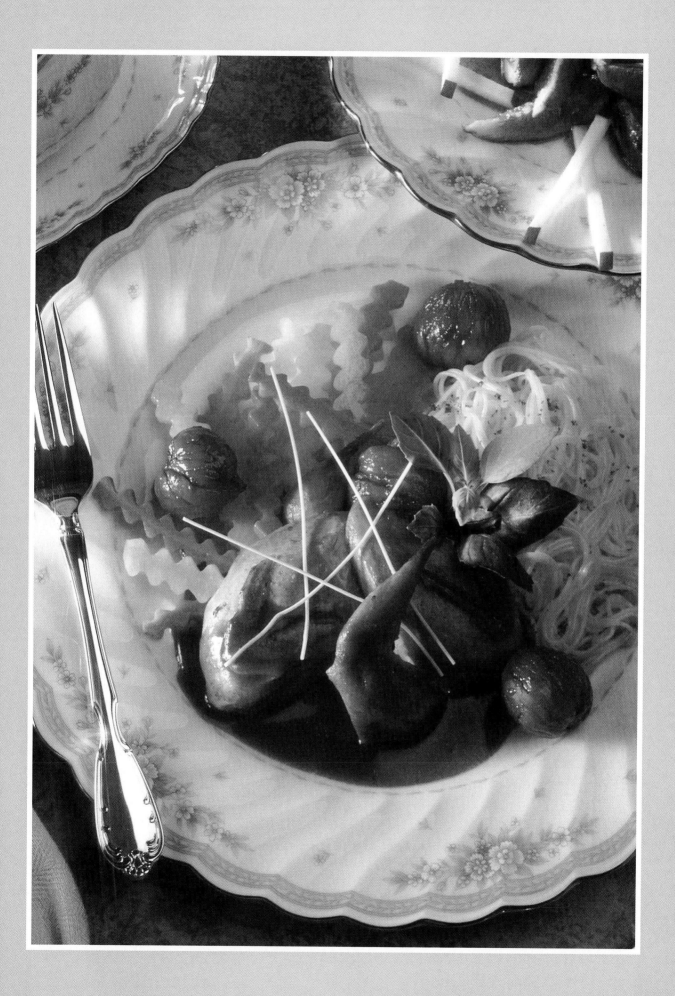

STUFFED TURKEY

10 SERVINGS

Preparation Time: 25 minutes

Cooking Time: approximately 2 hours

1 8 to 10 lb (4 to 5 kg) turkey
 lemon juice
 poultry spices, to taste
 pepper, to taste
 paprika, to taste

STUFFING

1/4 cup (50 ml) finely chopped onion
1 cup (250 ml) chopped celery
3 tbsp (50 ml) butter
1 lb (500 g) ground beef or veal
2 cups (500 ml) cooked rice
 pepper, to taste
 savory, to taste

Clean and dry the turkey, taking care to remove the giblets. Baste the turkey with lemon juice and season to taste. Set aside.

STUFFING

In a microwave safe dish, cook the onion and celery in butter at high heat for 2 to 4 minutes. Add the ground meat and continue cooking at medium heat for 4 to 5 minutes, stirring twice. Incorporate the cooked rice and season to taste. Let the stuffing set for 10 minutes.

Fill the interior of the turkey with the stuffing.

Preheat the oven to 350°F (180°C). Place the turkey in a roasting pan. Cook for 3 hours. Serve.

TURKEY KIEV

4 SERVINGS

Preparation Time: 20 minutes

Cooking Time: 8 minutes

4 turkey breasts
1 tbsp (15 ml) butter
1 dash of chive
1 pinch of garlic powder
 lemon juice
1 pinch of paprika
1 pinch of pepper
2 whole eggs, beaten

BREADCRUMBS

1/2 cup (125 ml) breadcrumbs
1/3 cup (75 ml) grated sbrinz cheese
1 tsp (5 ml) chopped, fresh parsley
1 tsp (5 ml) paprika

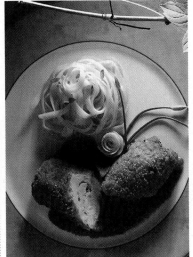

In a bowl, mix together the butter, chives, garlic powder, lemon juice, paprika and pepper. Keep cool. Place the turkey breasts between two pieces of plastic wrap or aluminum foil and flatten to 1/4 in (0.5 cm) thick by using a rolling pin or meat pounder.

Mix together all the bread crumb ingredients. Place a little of the seasoned butter on each turkey breast.

Roll up the turkey and dip it in the egg and then in the breadcrumbs.

Secure each turkey scallop with toothpicks and place them on a microwave plate. Cook for 4 minutes, uncovered, at medium-high heat.

Continue cooking for 4 minutes at medium-high heat or until the turkey is cooked. Let stand for 2 minutes and serve with a tomato sauce.

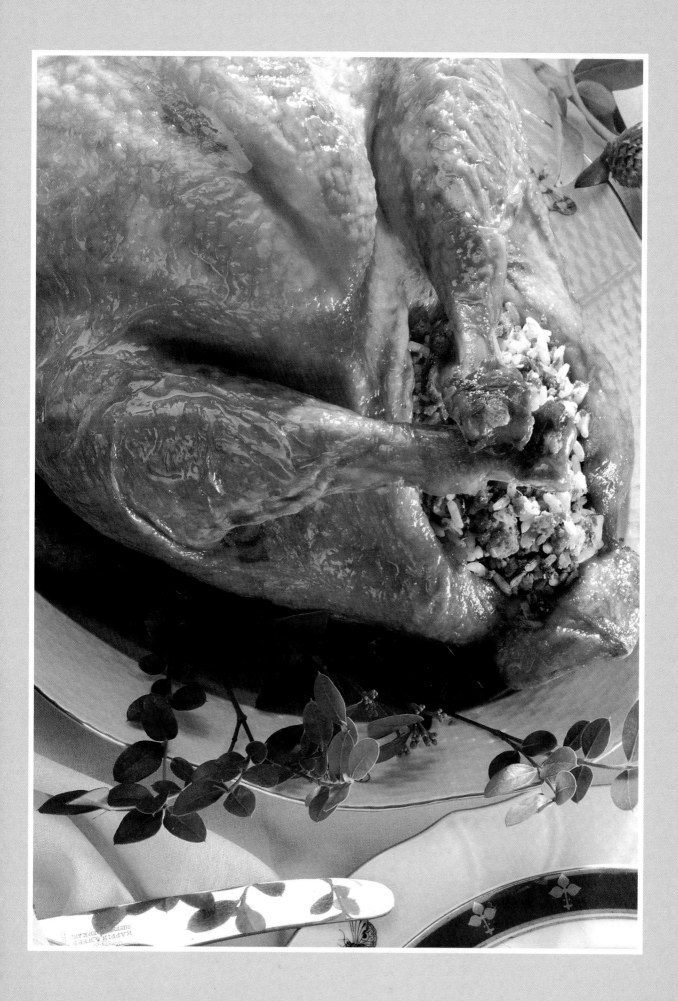

ROLLED TURKEY BREASTS

4 SERVINGS

Preparation Time: 25 minutes
Cooking Time: 20 to 25 minutes

7 oz (200 g) cooked ham, fat removed
and cut into small cubes
1 green or red pepper, diced
2 tsp (30 ml) finely chopped,
fresh parsley
2 tsp (30 ml) port or unsweetened
apple juice
1 egg white
2 pinches of tarragon or thyme
pepper, to taste
4 turkey breasts, flattened
8 leaves of romaine lettuce or
cabbage leaves, blanched
1/2 cup (125 ml) chicken stock
1/2 cup (125 ml) tomato sauce
boiled potatoes
1 tsp (5 ml) fresh parsley

Preheat the oven to 350°F (180°C).

Mix together the ham, pepper, chopped parsley, port or apple juice, egg white, tarragon or thyme and pepper.

Spread the mixture on the center of each turkey breast. Roll up and season.

Wrap in lettuce leaves.

Place in a baking dish, cover with stock and bake for 20 to 25 minutes.

Slice the turkey rolls into thick rings. Place on a plate with the tomato sauce.

Accompany with boiled potatoes and garnish with parsley.

SUNDAY TURKEY

4 SERVINGS

Preparation Time: 25 minutes
Cooking Time: 20 minutes

4 2 oz (60 g) turkey breasts, flattened
1 tbsp (15 ml) butter
2 tbsp (25 ml) finely chopped shallots
1/2 tsp (2 ml) garlic powder
1/2 tsp (2 ml) dry thyme
3/4 cup (175 ml) cooked spinach, chopped
1/4 cup (50 ml) grated Swiss cheese
BREADING
1/4 cup (50 ml) crushed cornflakes
1 tbsp (15 ml) chopped, fresh parsley
1 tsp (5 ml) paprika
1 tbsp (15 ml) melted butter

In a pan, melt the butter, add the shallots, garlic powder and thyme, cook for 2 minutes. Add the spinach and cook for 5 minutes. Let cool and add the cheese.

Spread the mixture on each turkey breast and roll up; set aside.

In a bowl, mix together all of the breading ingredients and dip each turkey roll in it; coat well. Place the rolls in a baking dish and bake for 10 minutes at 350°F (180°C). Serve.

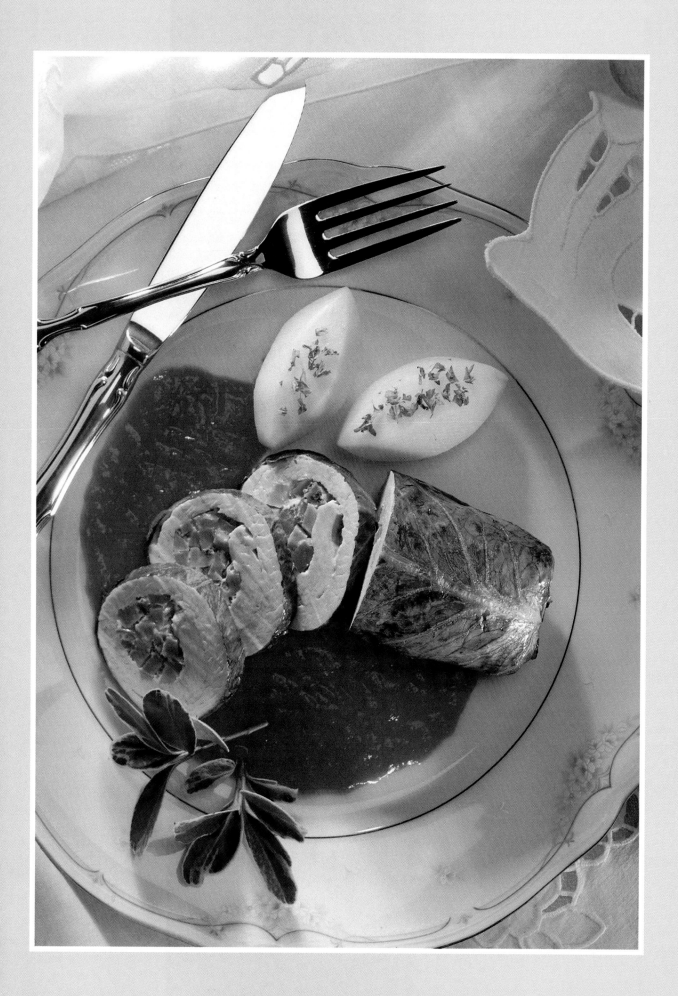

TURKEY FILETS WITH GOAT CHEESE

4 SERVINGS

Preparation Time: 20 minutes
Cooking Time: 30 minutes

2 tsp	(10 ml) olive oil
2 tsp	(10 ml) butter
1 1/2 lbs	(750 g) turkey filets
4	medium endives, washed
	salt and pepper, to taste
2 tbsp	(25 ml) chopped shallots
1	cluster of spices (1 bay leaf,
	1 sprig of thyme, and
	1 sprig of parsley)
1 cup	(250 ml) dry white wine
1 1/2 cups	(375 ml) chicken stock,
	skimmed of fat
1/2 cup	(125 ml) 35% cream
1/2 cup	(125 ml) goat cheese
1 tsp	(5 ml) melted butter
1 tsp	(5 ml) all-purpose flour
GARNISH	
	grapes and pecans

Preheat the oven to 350°F (180°C). In a large ovenproof skillet, heat the oil and melt the butter.

Add the turkey filets and endives; season and cook for 2 to 3 minutes on each side.

Add the shallots, cluster of spices, white wine and chicken stock. Place in the oven and bake for approximately 10 to 12 minutes. Remove the turkey filets and endives; keep warm.

Return the pan to the stove top and incorporate the cream, goat cheese and the mixture of butter and flour. Let simmer until thick.

Serve the endives, garnished with the sliced turkey filets. Cover with the goat cheese sauce, and garnish with the grapes and pecans.

TURKEY WITH APPLES

4 SERVINGS

Preparation Time: 15 minutes
Cooking Time: 30 minutes

5	4 oz (125g) turkey filets
1	egg white
1/2 cup	(125 ml) 15% cream
2	apples, seeded and diced
	salt and pepper, to taste
1 1/2 cups	(375 ml) apple juice
2 tsp	(10 ml) butter
2 tbsp	(25 ml) chopped shallots
1 1/2 cups	(375 ml) brown sauce,
	store bought

In a food processor, mix together one turkey filet (cut into pieces), with the egg white. Slowly add the cream and season; set aside.

On a cutting board, cut the four pieces of turkey in two, lengthwise, and flatten between sheets of plastic wrap.

Preheat the oven to 350°F (180°C). Garnish the four slices of turkey with the stuffing and cover with the other four slices; season. Place in a greased, baking dish. Cover with diced apples and apple juice. Bake for 12 to 15 minutes.

Remove the turkey filets and keep warm. In a pan, melt the butter and sauté the shallots. Add the cooking juice and brown sauce; let reduce until desired consistency.

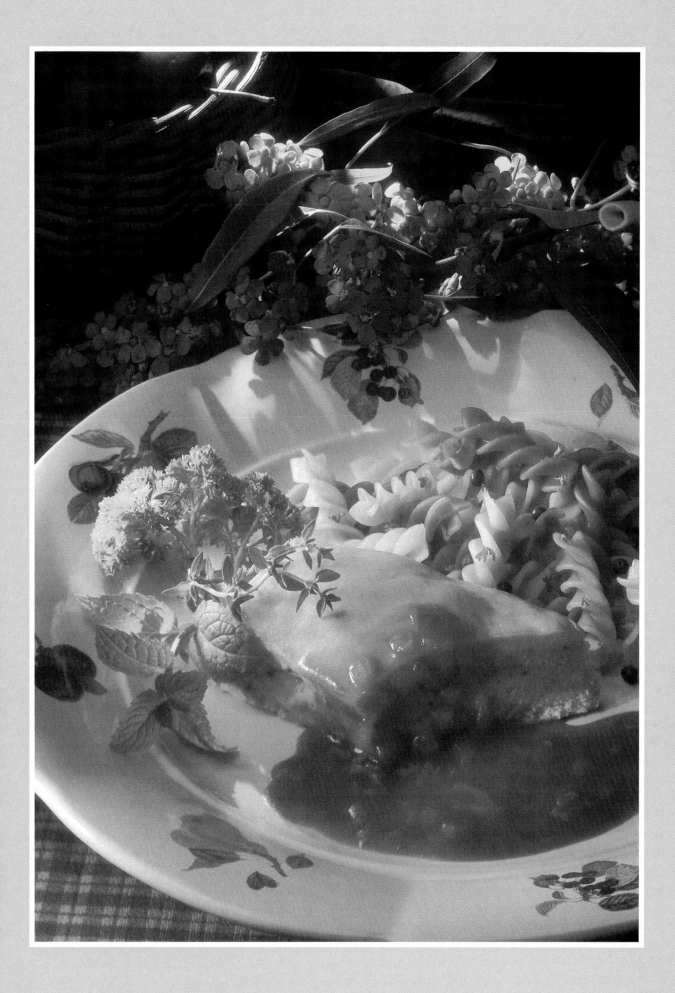

TURKEY BREASTS WITH KIDNEY BEANS

4 TO 6 SERVINGS
Preparation Time: 15 minutes
Cooking Time: 1 hour 45 minutes

1 1/2 cups	(375 ml)	kidney beans
1 1/2 lb	(750 g)	boneless turkey breast
2 tbsp	(25 ml)	butter
1/2 cup	(125 ml)	chopped onions
1/2 cup	(125 ml)	diced celery
1/2 cup	(125 ml)	diced carrots
2 tbsp	(25 ml)	minced garlic
19 oz	(540 ml)	diced tomatoes
1 cup	(250 ml)	dry white wine
2 cups	(500 ml)	chicken stock, skimmed of fat
1/2 cup	(125 ml)	unsweetened orange juice
1		bay leaf
2		sprigs of parsley
		salt and pepper
3 tbsp	(50 ml)	chopped, fresh basil
3 tbsp	(50 ml)	orange zests

In a large bowl, soak the kidney beans in water for 12 hours. Drain, and rinse with cold water; set aside.

Cut the turkey breast into 4 portions. In a pot, melt the butter, add the turkey, onions, celery, carrots and garlic and cook for a few minutes. Add the tomatoes.

Add the white wine, chicken stock and orange juice. Incorporate the kidney beans, bay leaf and parsley. Season and let simmer over low heat for about 1 1/2 hours. Add water if necessary.

A few minutes before the end of cooking, add the basil and orange zest.

When serving, slice the pieces of turkey and place them on a bed of kidney beans.

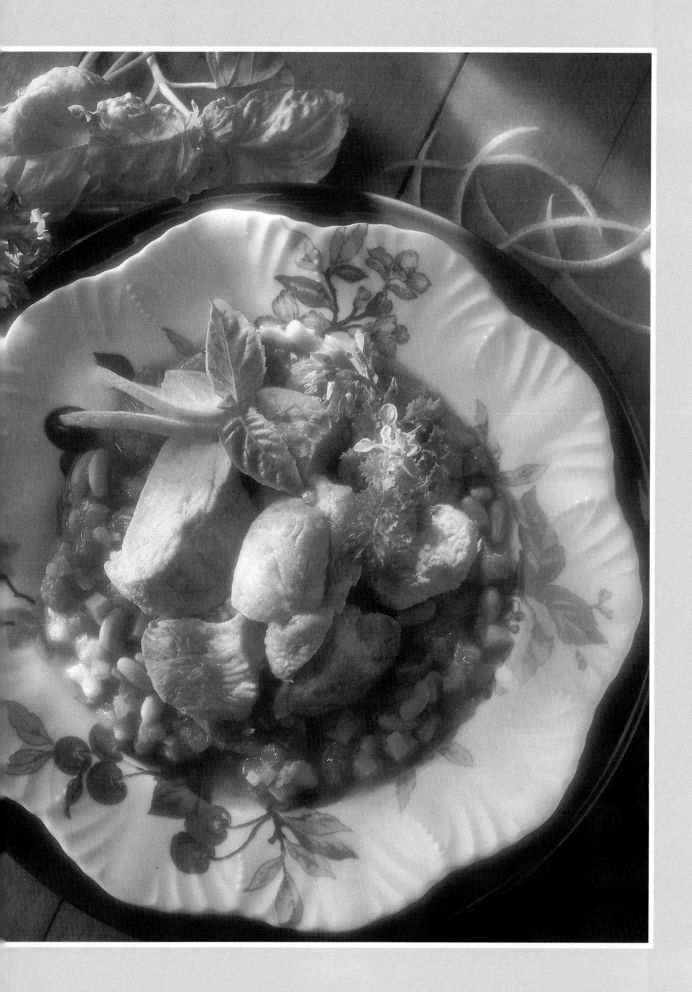

TURKEY STUFFED WITH SPINACH

4 SERVINGS

Preparation Time: 20 minutes

Cooking Time: 20 minutes

8	2 oz (60 g) turkey breasts
1 tbsp	(15 ml) butter
2 tbsp	(25 ml) finely chopped shallots
1/2 tsp	(2 ml) garlic powder
1/2 tsp	(2 ml) thyme
1 1/2 cups	(375 ml) chopped, cooked spinach
1/2 cup	(125 ml) grated Swiss cheese

BREADCRUMBS

1/2 cup	(125 ml) Corn Flakes, crumbled
1 tbsp	(15 ml) parsley
1 tsp	(5 ml) paprika
2 tbsp	(25 ml) melted butter

Place the turkey between two sheets of thick plastic wrap and flatten, to 1/8 in (3 mm) thick by using a meat pounder or rolling pin.

In a pan, melt the butter. Add the shallots, garlic powder and thyme, cook for 2 minutes. Add the spinach and cook for 5 minutes. Let cool and add the cheese.

Spread the mixture on each turkey breast, and roll up; set aside.

Mix together the breadcrumb ingredients and coat each turkey breast. Place the rolls in a baking dish and bake for 10 minutes at 350°F (180°C). Serve hot.

OLD FASHIONED TURKEY ROLL-UPS

4 SERVINGS

Preparation Time: 20 minutes

Cooking Time: 20 minutes

4 oz	(125 g) ground turkey
2	slices of bread, crumbled
2	slices of bacon, cooked and chopped
1	egg
2 tbsp	(25 ml) milk
2 tbsp	(25 ml) chopped fresh parsley
1/2 tsp	(2 ml) dry savory
1/2	green onion, chopped salt and pepper, to taste
4	6 oz (180 g) turkey breasts, flattened
2 tsp	(10 ml) butter salt and pepper, to taste
1	green onion, sliced
1	bay leaf
1	sprig of thyme
1	sprig of parsley
1/2 cup	(125 ml) dry white wine or apple juice
1 cup	(250 ml) chicken stock
1 cup	(250 ml) brown sauce, store bought

In a bowl, combine the ground turkey, bread, bacon, egg, milk, parsley, savory and green onion; season. Spread the mixture on each turkey breast. Roll up tightly and secure with toothpicks or butcher's string.

In a large pan, melt the butter and lightly cook the turkey on each side; season. Add the green onion, spices, white wine, chicken stock and brown sauce. Cover and let simmer over low heat for 15 to 20 minutes, (let the sauce reduce if necessary). Serve.

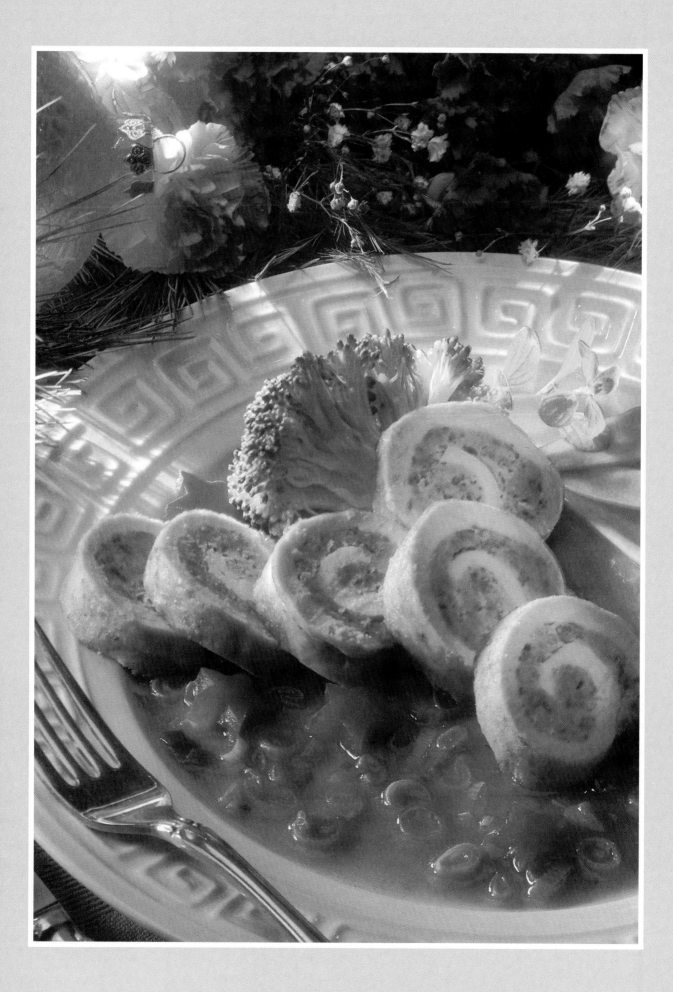

CHICKEN LEGS WITH OYSTER MUSHROOMS

4 SERVINGS

Preparation Time: 15 minutes

Cooking Time: 15 minutes

12 to 16	slices of boneless chicken legs
	salt and pepper
1/4 cup	(50 ml) all-purpose flour
2 tbsp	(30 ml) olive oil
1 lb	(500 g) sliced oyster mushrooms
	salt and pepper
2	shallots, finely chopped
1/2 cup	(125 ml) dry white wine
1/2 cup	(125 ml) chicken stock
1 tsp	(5 ml) lemon zest
1/2 tsp	(2 ml) peanut oil or 1/2 tsp (2 ml) soya oil
2 tbsp	(25 ml) butter
2 tbsp	(25 ml) finely chopped fresh basil

Season and coat the chicken slices with flour. In a pan, heat the olive oil over medium-high heat and cook each slice on each side for 5 to 10 minutes. Keep warm. Add the mushrooms and lightly sauté over high heat. Season and set aside with the chicken.

In a pan, reduce the white wine with the shallots. Add the chicken stock, lemon zest, peanut oil, or soya oil; reduce by half. Over medium heat, whisk in the butter and add the basil; season.

Build a nest of oyster mushrooms on the bottom of each serving plate. Place the chicken on top and cover with sauce.

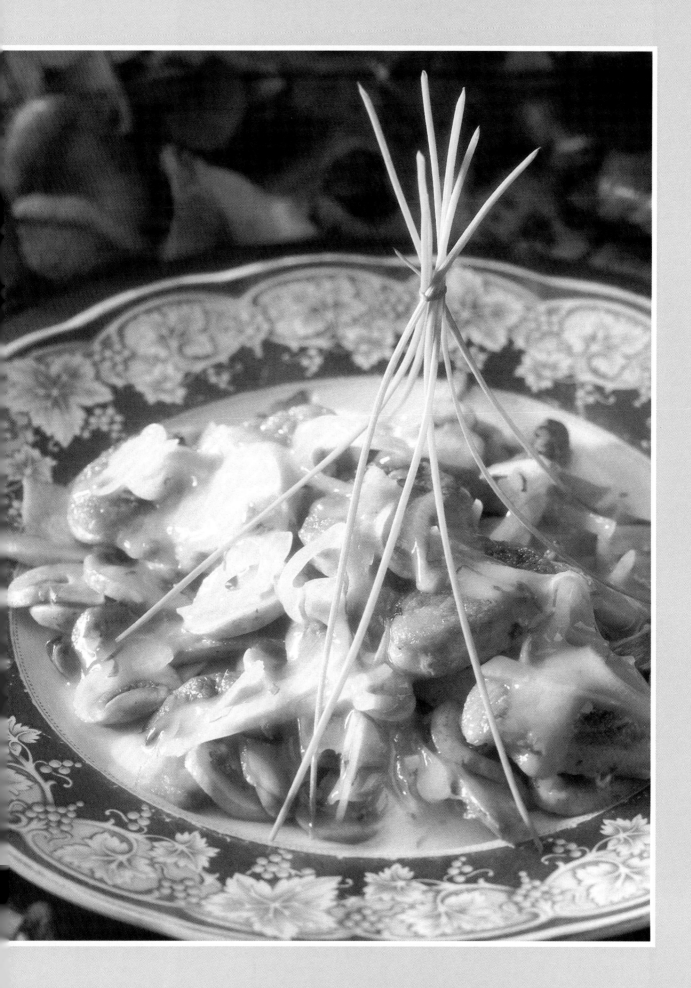

MILAN CHICKEN CASSEROLE

4 SERVINGS

Preparation Time: 15 minutes

Cooking Time: 30 minutes

2 tsp	(10 ml) olive oil
1 lb	(500 g) chicken legs, with no backs, boneless and skinless
2 tbsp	(25 ml) tomato paste
1/2 tsp	(2 ml) basil
1/2 tsp	(2 ml) dry oregano
	salt and pepper
1 cup	(250 ml) dry white wine or chicken stock
3 cups	(750 ml) chicken stock
2 tsp	(10 ml) olive oil
3/4 cup	(175 ml) chopped onions
2 cups	(500 ml) round rice (Italian)
	salt and pepper
1/2 cup	(125 ml) grated Parmesan cheese

GARNISH

1	tomato, seeded and diced
1 tbsp	(15 ml) chopped, fresh parsley
12	black olives, pitted

In a large pan, heat the olive oil and cook the chicken for 2 to 3 minutes on each side until golden. Add the tomato paste, basil and oregano; season.

Add the white wine and chicken stock. Cover and let simmer over low heat for 10 to 12 minutes. Remove the chicken and set aside.

In another pan, heat the olive oil and brown the onions. Add the rice and continue cooking for 1 minute. Season and cover with the cooking juice, so that the rice is covered. Let simmer for 12 to 14 minutes, while adding cooking juice or water as needed.

Add the chicken and Parmesan cheese, mix well. Serve garnished with diced tomatoes, parsley and black olives.

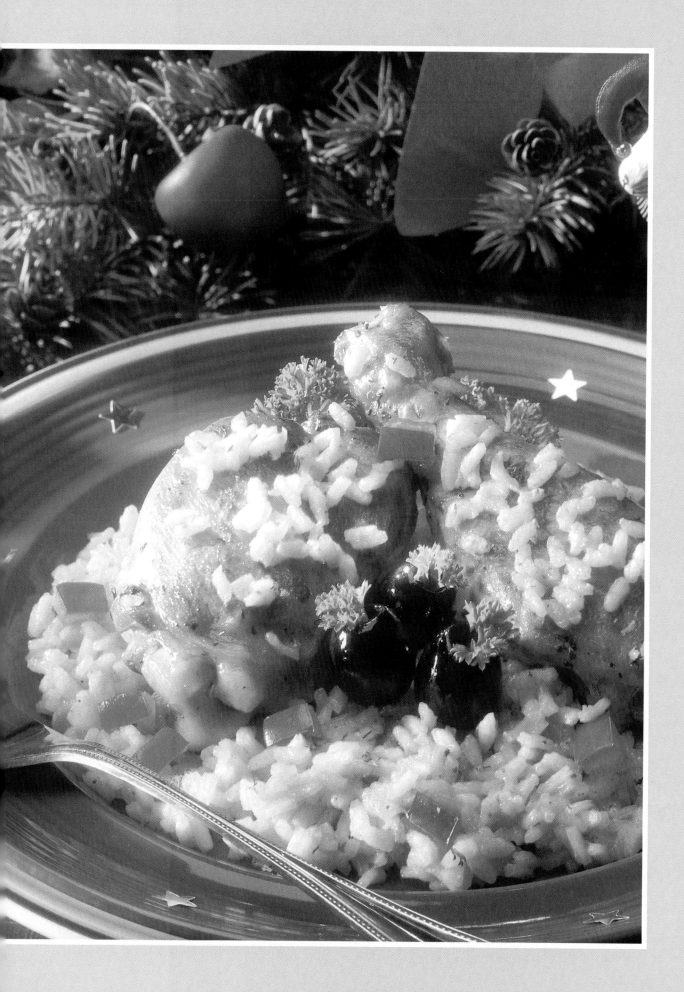

CHICKEN CASSEROLE WITH BARLEY

4 SERVINGS

Preparation Time: 15 minutes

Cooking Time: 45 minutes

1 tbsp	(15 ml) butter
1	2 1/2 lbs (1.25 kg) chicken cut into 8 pieces
	salt and pepper, to taste
1 cup	(250 ml) largely cubed onions
1/2 cup	(125 ml) largely cubed celery
1 1/2cups	(375 ml) turnip sticks
1 1/2cups	(375 ml) carrot sticks
1 tsp	(5 ml) minced garlic (optional)
5 cups	(1.25 L) chicken stock, skimmed of fat
1 cup	(250 ml) barley

GARNISH

2 tbsp	(25 ml) chopped, fresh parsley
8	black olives

In a large pan, melt the butter, and cook the chicken; season.

Add the onions and celery and continue to cook. Add the turnip, carrots, garlic and chicken stock. Let simmer for 35 to 40 minutes.

Midway through the cooking, add the barley. Serve on a platter, and garnish with parsley and olives.

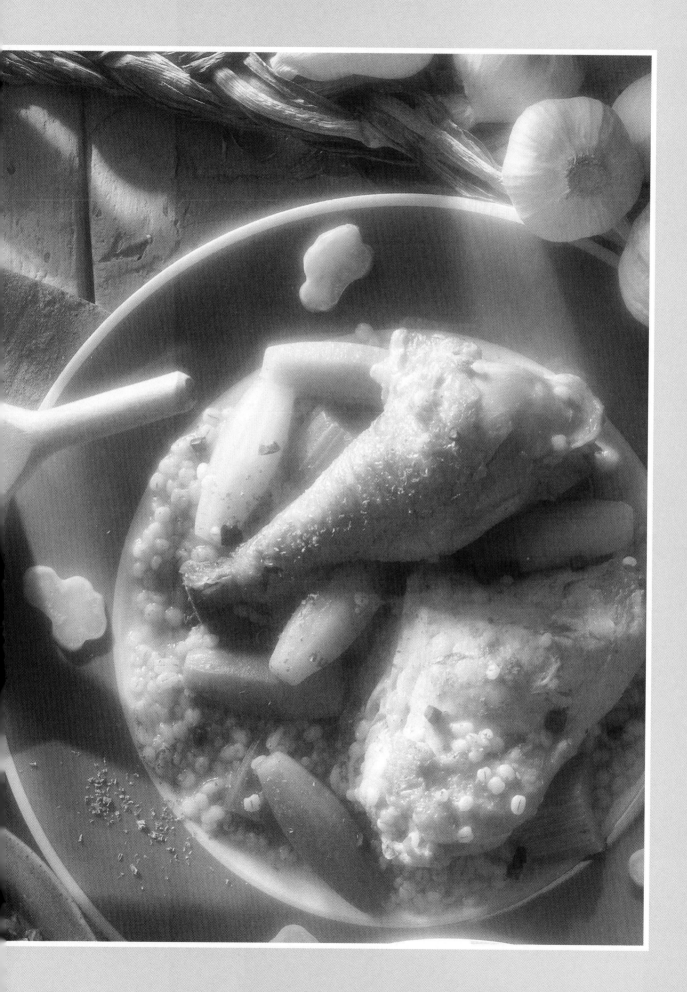

JAMBALAYA

4 SERVINGS

Preparation Time: 20 minutes
Cooking Time: 30 minutes

1 tsp	(5 ml) corn oil
1 tsp	(5 ml) butter
1/2	chicken, boneless and cut into 4 pieces
2 oz	(60 g) lean ham
2	smoked sausages
8	jumbo shrimp, deveined
1/2 cup	(125 ml) chopped onions
1/2 cup	(125 ml) coarsely chopped celery
1	small zucchini cut into pieces
1	red or green pepper cut into pieces
1 tbsp	(15 ml) minced garlic
19 oz	(540 ml) diced tomatoes
1 1/2 cups	(375 ml) long grain rice
1 1/2 cups	(375 ml) chicken stock, skimmed of fat
1 tbsp	(15 ml) hot sauce, store bought
1	cluster of spice (1 bay leaf, 1 sprig of thyme, 1 sprig of parsley)
10 oz	(284 ml) canned corn
19 oz	(540 ml) canned red beans

In a large pan, heat the oil and butter, and cook the chicken, ham, sausage and shrimp.

Add the onion, celery, zucchini, peppers, and garlic. Cook until the vegetables soften.

Add the diced tomatoes, chicken stock, rice, hot sauce, and cluster of spices. Let simmer for 15 to 20 minutes, or until the stock is completely absorbed. Add the corn and red beans; serve.

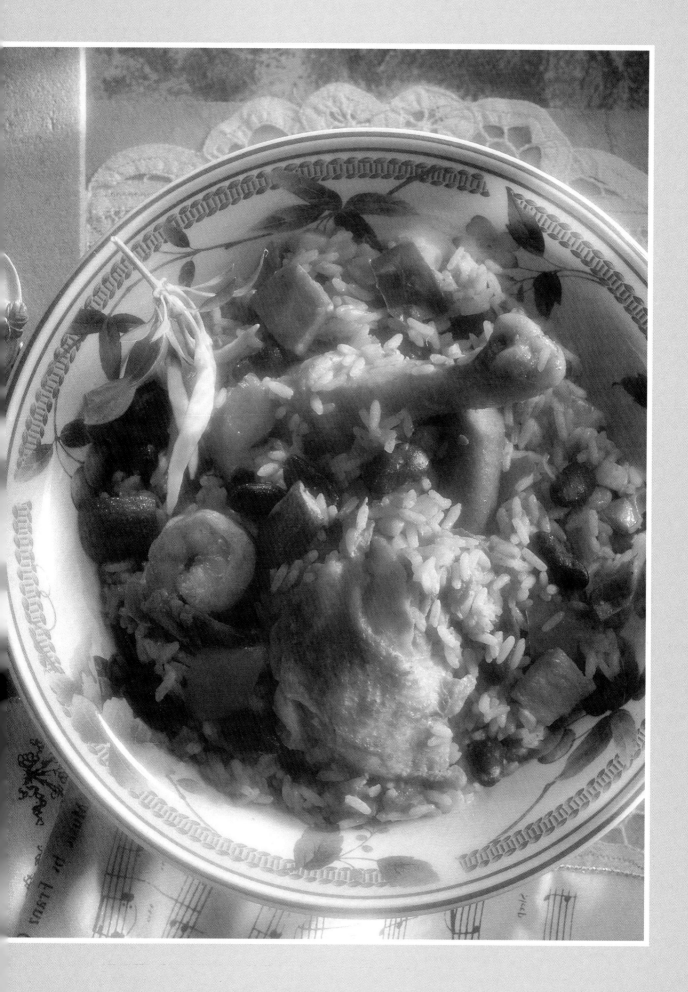

TUSCANY RISOTTO

4 SERVINGS

Preparation Time: 15 minutes
Cooking Time: 30 minutes

1 tbsp	(15 ml) olive oil	
1 tsp	(5 ml) butter	
1	(1.25 kg) 2.5 lbs chicken, cut into 8 pieces	
2 tbsp	(25 ml) tomato paste	
	salt and pepper, to taste	
1/2 tsp	(2 ml) dried basil	
1/2 tsp	(2 ml) dried oregano	
1 cup	(250 ml) dry white wine or chicken stock, skinned of fat	
4 cups	(1 L) chicken stock, skimmed of fat	
1 tbsp	(15 ml) olive oil	
1/2 cup	(125 ml) chopped onions	
2 cups	(500 ml) round rice (Italian)	
1/2 cup	(125 ml) grated Parmesan or mozzarella cheese	

GARNISH

1 tbsp	(15 ml) chopped, fresh parsley
12	black olives, pitted

In a large pan, heat the oil and melt the butter by gradually increasing the heat. Cook the chicken on all sides and add the tomato paste. Season and add the basil and oregano.

Add the white wine and chicken stock. Let simmer for 20 to 25 minutes. Remove the chicken and keep warm.

In another pan, heat the oil and brown the onions. Add the rice and sauté lightly. Cover with just enough of the cooking juice to cover the rice. Let simmer for 12 to 14 minutes, while adding, if necessary, extra cooking juice or water so that the rice is always just covered.

Incorporate the chicken and the cheese, mix well. Garnish with parsley and olives.

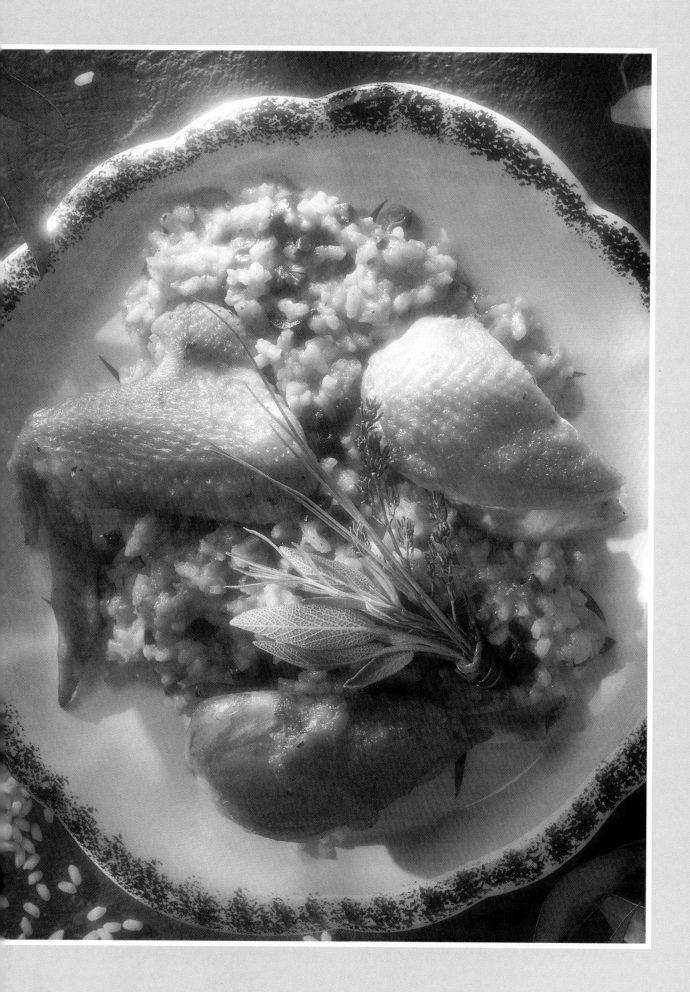

CHICKEN WITH BEER

4 SERVINGS
Preparation Time: 15 minutes
Cooking Time: 30 minutes

1 tbsp (15 ml) olive oil
2.5 lbs (1.25 kg) chicken cut into 8 pieces
2 tbsp (25 ml) all-purpose flour
2 tbsp (25 ml) paprika
1 tbsp (15 ml) tomato paste
3/4 cup (175 ml) chopped onions
1 green or red pepper, chopped
1 tsp (5 ml) minced garlic
28 oz (796 ml) tomatoes with fine
herbs, peeled and lightly crushed
12 oz (341 ml) beer
1 cup (250 ml) chicken stock,
skimmed of fat
salt and pepper, to taste
1 tbsp (15 ml) cornstarch,
diluted in a little water

Lightly coat the chicken with flour. In a large baking dish, heat the oil and roast the chicken for approximately 5 minutes; sprinkle with paprika.

Add the tomato paste, onion, pepper, garlic, tomato, beer and chicken stock. Season and let simmer, covered, for 20 to 25 minutes over low heat. Thicken the sauce with cornstarch.

Serve on rice pilaf and accompany with vegetables of choice.

RED CURRY CHICKEN WITH COCONUT MILK

2 SERVINGS
Preparation Time: 20 minutes
Cooking Time: 10 minutes

1 tbsp (15 ml) vegetable oil
1 tbsp (15 ml) Cayenne pepper and
curry paste
1 boneless chicken cut into pieces,
or 2 chicken breasts,
skinless and boneless
2/3 cup (150 ml) coconut milk
1 can of sliced bamboo shoots
1 cup (250 ml) green beans, cooked and
cut into pieces
salt to taste
1/2 tsp (2 ml) sugar
GARNISH
4 to 5 basil leaves
1/2 red pepper cut into small pieces
1/2 green pepper cut into small pieces

Heat the oil and Cayenne pepper and curry paste in a pan. Add the chicken and sauté for a few minutes over high heat.

Add the coconut milk, bamboo shoots and green beans. Reduce the heat and continue cooking until the chicken is cooked, approximately 10 minutes. Add the salt and sugar.

Place on a serving platter. Garnish with the basil and green and red pepper.

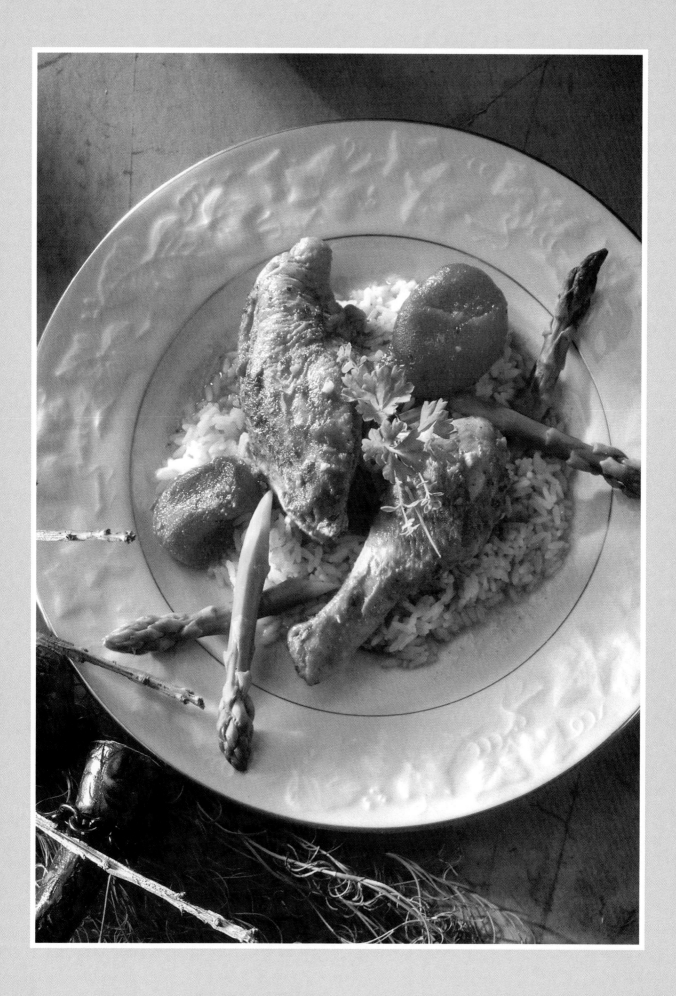

MUSHROOM RAVIOLI

4 SERVINGS

Preparation Time: 20 minutes
Cooking Time: 25 minutes

2 tsp (10 ml) butter
4 shallots or 1 red onion, chopped
1 1/2 lb (700 g) chopped mushrooms
2 tbsp (25 ml) chopped, fresh parsley
1/3 cup (75 ml) grated Gruyère cheese
28 won-tons
water, in sufficient quantity
3 cups (750 ml) chicken stock, skimmed of fat
1 1/2 cups (375 ml) tomato sauce
1 tbsp (15 ml) butter
1 lb (500 g) spicy BBQ chicken wings
2 tbsp (25 ml) chopped, fresh chives

In a nonstick pan, melt the butter over medium heat. Cook the shallots for 4 minutes, incorporate the mushrooms. Cook for approximately 10 minutes, until the liquid has evaporated, and add the parsley. Place in a bowl and let cool. Add the Gruyère cheese when the mixture has completely cooled.

Stuff the won ton dough with the mushroom mixture and form ravioli. Seal the sides with a little water.

In a pan, bring the chicken stock to a simmer. Poach the ravioli in the stock and set aside in a little cooled chicken stock.

Reduce the rest of the broth until almost dry, then add the tomato sauce. Reduce the heat and simmer gently.

In a pan, melt the butter and cook the chicken wings over low heat. Line a platter or a plate with the sauce, garnish with the chicken wings and ravioli, and sprinkle with chives. Serve.

CHICKEN BREASTS WITH CITRUS HOLLANDAISE SAUCE

4 SERVINGS

Preparation Time: 20 minutes
Cooking Time: 6 minutes

2 egg yokes, medium
2 tbsp (25 ml) dry white wine
1 tsp (5 ml) finely grated lemon zest
1 tsp (5 ml) finely grated orange zest
salt and pepper, to taste
2/3 cup (150 ml) softened butter
2 tbsp (25 ml) fresh lemon juice
2 tbsp (25 ml) fresh orange juice
1/2 cup (125 ml) 35% cream, whipped
4 chicken breasts, flattened
salt and pepper, to taste
2 tbsp (25 ml) butter

In a double boiler, whip together the egg yolks, white wine, lemon and orange zests for 3 minutes; season.

Gradually add the butter, while whipping, until the sauce emulsifies. When the sauce is consistent (like mayonnaise), remove from the heat and add the lemon and orange juice. Add the whipped cream, while mixing delicately.

Season the chicken breasts. In a pan, melt the butter, while slowly increasing the heat. Sauté the chicken over medium heat, for three minutes on each side.

Serve the chicken covered with the citrus Hollandaise sauce.

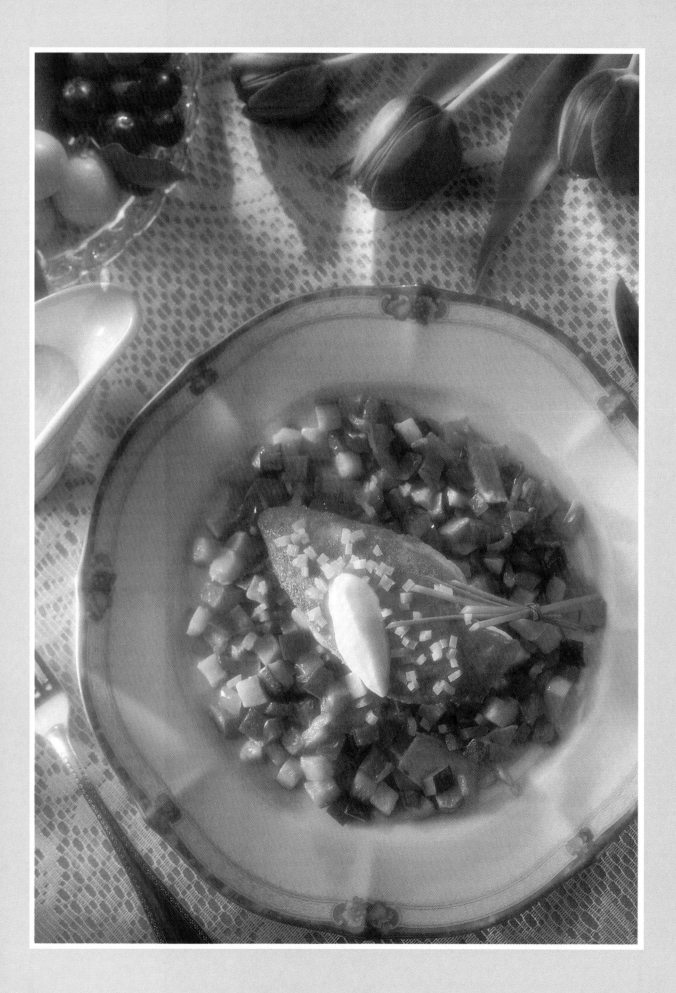

CHICKEN BREASTS WITH CARROT AND PEACH SAUCE

4 SERVINGS

Preparation Time: 10 minutes
Cooking Time: 10 minutes

1 tsp	(5 ml) vegetable oil
4	chicken breasts, skinned and flattened
1 tbsp	(15 ml) chopped shallots or green onion
1 tsp	(5 ml) ground coriander seeds
3/4 cup	(175 ml) unsweetened orange juice
3/4 cup	(175 ml) chicken stock, skimmed of fat
1 tbsp	(15 ml) butter
1 tbsp	(15 ml) all-purpose flour
1/2 cup	(125 ml) cut and cooked carrots
2	peaches, peeled, pitted and sliced
1 tbsp	(15 ml) chopped, fresh parsley

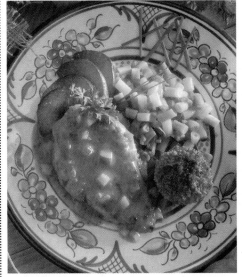

In a pan, heat the oil and cook the chicken breasts over medium heat for 1 minute on each side. Add the shallots or the green onion and the coriander; brown for 1 minute.

Add the orange juice and chicken stock; let simmer for 5 minutes. Remove the chicken and keep warm.

Thicken the sauce with a mixture of butter and flour. Add the carrots, peaches and parsley, and let simmer for 2 minutes.

Serve the chicken breasts covered with the carrot and peach sauce.

CLASSIC TOURNEDOS

4 SERVINGS

Preparation Time: 10 minutes
Cooking Time: 10 minutes

2 tbsp	(25 ml) butter
6	shallots, thinly sliced
1/2 cup	(125 ml) dry red wine
1 cup	(250 ml) brown sauce, store bought
1/2 tsp	(2 ml) thyme
	salt and pepper, to taste
1/2 cup	(125 ml) 35% cream
4	6 oz (175 g) tournedos (slices of beef)
12	chopped Shallots

In a pan, melt half of the butter and sauté the shallots for 2 minutes. Add the red wine and let reduce by half. Add the brown sauce, thyme, salt and pepper and cook over low heat for 5 minutes. Add the cream and set aside.

In a frying pan, melt the remaining butter. Season the tournedos and cook for 3 to 5 minutes on each side.

Place the tournedos on the plates. Reheat the sauce and pour over the tournedos. Garnish with the chopped shallots.

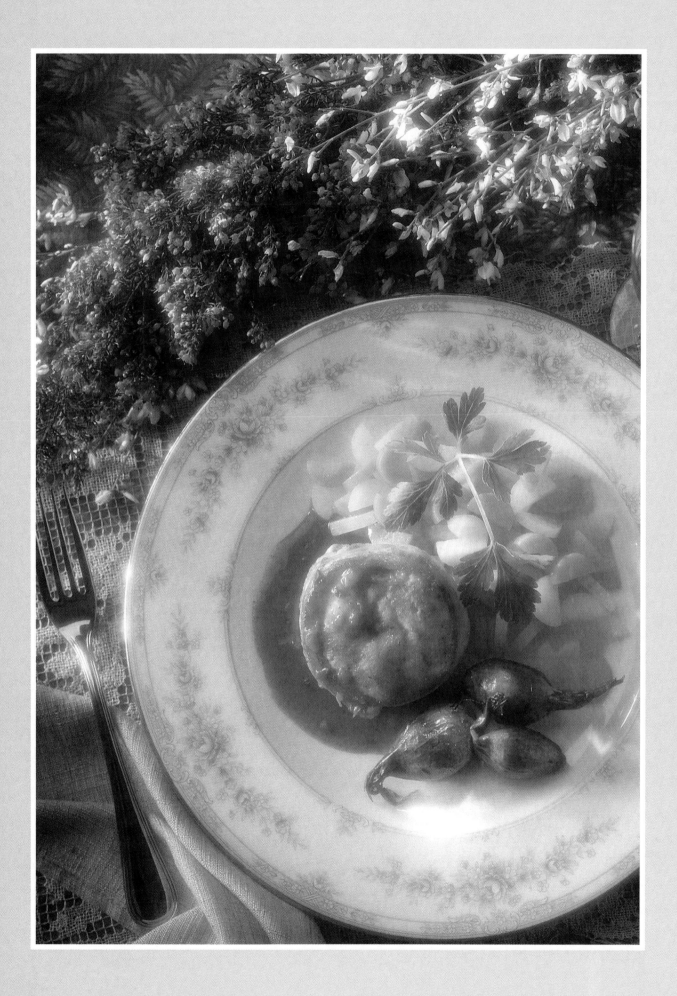

CHICKEN BREASTS WITH APPLES AND GOAT CHEESE

4 SERVINGS
Preparation Time: 15 minutes
Cooking Time: 30 minutes

1tsp	(5 ml) butter
2	apples, peeled, seeded and cut into slices
4	6 oz (180 g) chicken breast halves, boneless and skinless
6 oz	(180 g) goat cheese
	salt and pepper, to taste
2 tsp	(10 ml) butter
12 oz	(341 ml) beer
2 tbsp	(25 ml) chopped shallots
2	apples, seeded and diced
1 cup	(250 ml) brown sauce, store bought

GARNISH
fine herbs, of choice

In a pan, melt the butter over low heat and cook the apple slices for 1 minute, (just to soften lightly). Let cool and set aside. On a cutting board, cut the chicken breasts horizontally, and stuff with slices of apples and goat cheese.

Close and secure with butcher's string or toothpicks; season.

Preheat the oven to 350°F (180°C). In a pan, melt the butter and cook the chicken breasts for 1 minute on each side. Place in a pan and bake for 15 minutes or to your desired taste.

In a sauce pan, bring the beer to a boil and reduce by half; set aside. Put the pan back on the stove, add the shallots and the diced apples, sauté for 1 to 2 minutes; add the beer and brown sauce. Let simmer until the sauce thickens.

Serve the chicken on plates covered with the sauce, and garnish with fine herbs.

RICOTTA CHICKEN ROAST

4 SERVINGS

Preparation Time: 15 minutes

Cooking Time: 1 hour

2 tsp (10 ml) melted butter
2 tbsp (25 ml) lemon juice
1 tsp (5 ml) honey
2 tbsp (10 ml) chopped chervil or parsley
salt and pepper, to taste
1 1/2 lb (750 g) chicken breasts or legs
1 tsp (5 ml) butter
1 green onion, sliced
1 1/2 cups (375 ml) carrots, sliced and cooked
2 tbsp (25 ml) chopped chervil or parsley
1 cup (250 ml) chicken stock
1 tbsp (15 ml) cornstarch,
diluted in a little water
salt and pepper, to taste
1/2 cup (125 ml) ricotta cheese

Preheat the oven to 350°F (180°C).

In a small bowl, mix together the butter, lemon juice, honey and chervil or parsley. Brush the chicken with this mixture, and season. Place in a lightly buttered baking dish and bake for 40 to 45 minutes.

In a pan, melt the butter and sauté the green onions. Add the carrots, chervil and the chicken stock, season and let simmer for 5 minutes over low heat. Thicken with the cornstarch and add the ricotta cheese. When serving, cover with sauce.

ROASTED CHICKEN LEGS WITH ZUCCHINI AND OLIVES

4 SERVINGS

Preparation Time: 15 minutes

Cooking Time: 40 minutes

2 tsp (10 ml) vegetable oil
1 tsp (5 ml) butter
4 chicken legs, deboned
salt and pepper, to taste
2 tsp (10 ml) tomato paste
2 tbsp (25 ml) chopped shallots
1 tsp (5 ml) minced garlic
1 zucchini, diced
28 oz (796 ml) crushed tomatoes,
with fine herbs
1 cup (250 ml) green or black olives,
pitted
1 cup (250 ml) chicken stock
2 tsp (10 ml) cornstarch

In a large pan, heat the oil and butter. Cook the chicken legs for 3 to 4 minutes, turning regularly until golden; season. Add the tomato paste and let the chicken brown. Incorporate the shallots, garlic, zucchini, tomatoes, olives, chicken stock and cornstarch. Cover and simmer over low heat for 30 to 35 minutes. Serve with pasta.

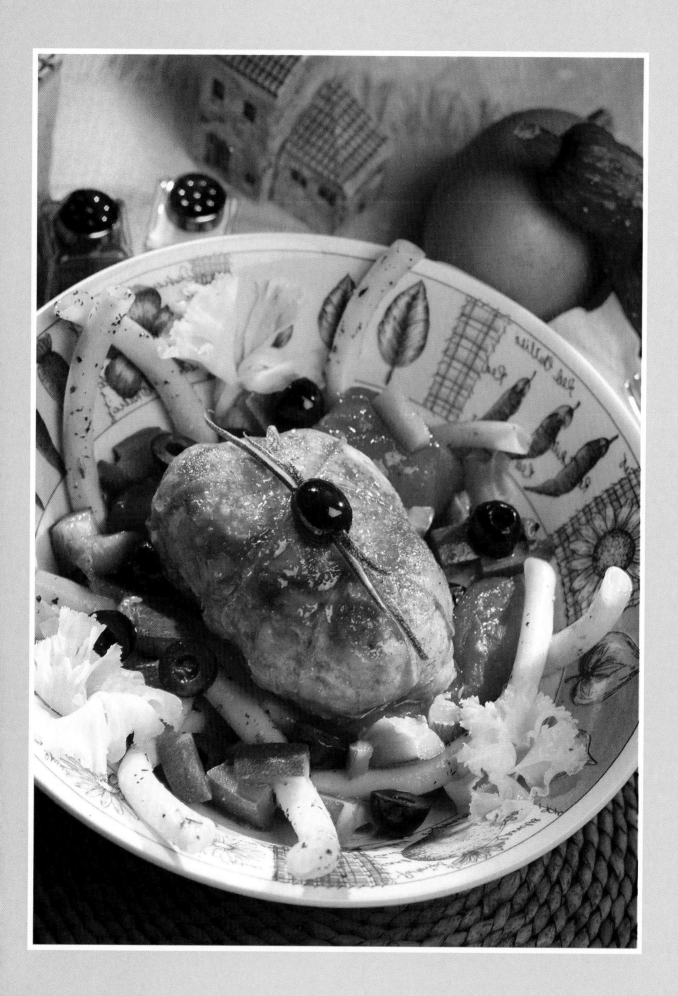

CHICKEN TOURNEDOS

4 SERVINGS

Preparation Time: 5 minutes

Cooking Time: 15 minutes

2 tsp	(10 ml) butter
4	chicken breast tournedos or chicken leg tournedos of 1/4 lb (150 g) each salt and pepper, to taste
2 tbsp	(25 ml) chopped shallots
1 tbsp	(15 ml) tomato paste
1 tbsp	(15 ml) paprika
1 tsp	(5 ml) tarragon
1 cup	(250 ml) beer
1 cup	(250 ml) brown sauce, store bought

In a large pan, melt the butter and cook the chicken tournedos for 4 to 5 minutes on each side; season.

Remove the tournedos from the pan and keep warm. Add the shallots to the pan and lightly sauté. Incorporate the tomato paste, paprika, tarragon, and beer; let reduceby half. Add the brown sauce and let simmer over low heat until the sauce has thickened.

Pour the paprika sauce over the chicken.

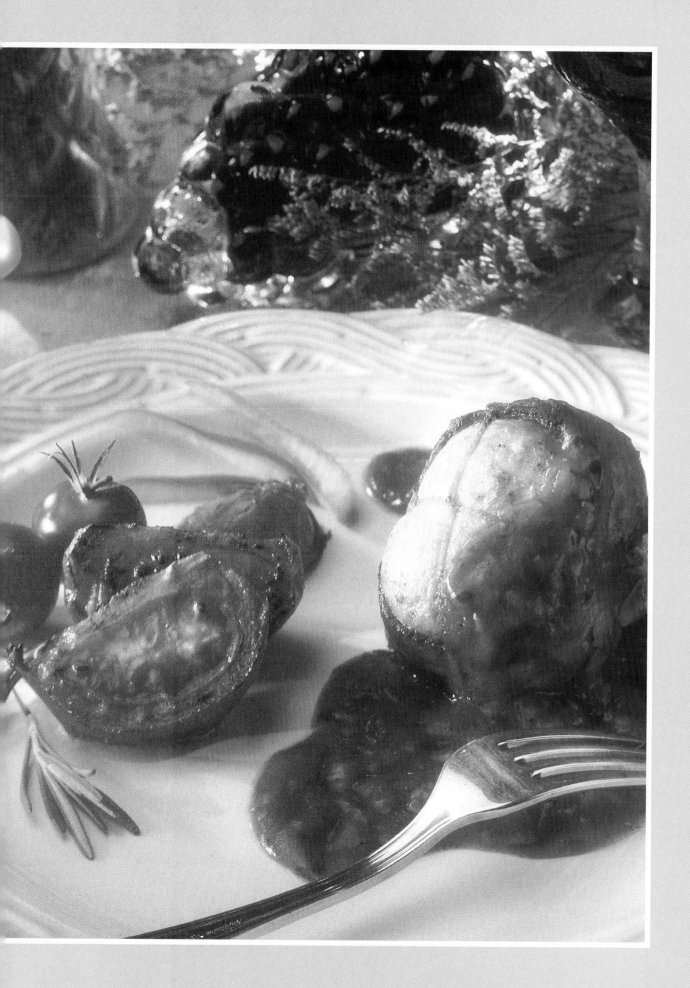

CHICKEN BREASTS WITH WATERCRESS SAUCE

4 SERVINGS

Preparation Time: 15 minutes
Cooking Time: 20 minutes

1 tsp (5 ml) corn oil
4 chicken breast halves, skinless and boneless
salt and pepper, to taste

SAUCE
1 tsp (5 ml) butter
2 tbsp (25 ml) chopped shallots
1 cup (250 ml) dry white wine or chicken stock, skimmed of fat
1 tsp (5 ml) black peppercorns
2 tsp (10 ml) butter
2 tsp (10 ml) all-purpose flour
1 tsp (5 ml) butter
2 cups (500 ml) watercress
1 cup (250 ml) plain yogurt

GARNISH
4 sprigs of watercress

Preheat the oven to 350°F (180°C). In an ovenproof skillet, heat the oil and cook the chicken breasts over medium heat for 2 to 3 minutes on each side. Season, and complete the cooking in the oven for 10 to 15 minutes, depending on the size of the breasts; set aside.

In another pan, melt the butter and lightly sauté the shallots. Add the white wine, and pepper and let reduce by half.

Thicken with a mixture of butter and flour. Season and pass through a strainer and set aside.

In another pan, melt the butter and lightly cook the watercress for 1 minute, over medium heat. Purée in a food processor or by using an electric mixer and add to the sauce. Bring to a boil and add the yogurt (do not simmer).

Cut the chicken breasts into thin strips, cover with sauce and garnish with watercress. Serve with vegetables of your choice.

CHICKEN WITH GOAT CHEESE AND RHUBARB SAUCE

4 SERVINGS

Preparation Time: 15 minutes
Cooking Time: 25 minutes

2 tsp (10 ml) butter
4 half breasts of chicken, boneless and skinned
salt and pepper, to taste
2 tbsp (25 ml) chopped shallots
1 cup (250 ml) thinly sliced rhubarb
1 cup (250 ml) cider
1 cup (250 ml) chicken stock
2 tbsp (25 ml) butter
2 tbsp (25 ml) all-purpose flour
1/2 cup (125 ml) 15% cream
4 oz (125 g) goat cheese

GARNISH
apple rings, grilled in the oven

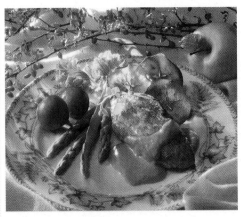

In a large pan, melt the butter and cook the chicken breasts for 2 to 3 minutes on each side; season. Add the shallots and the rhubarb and lightly brown. Add the cider and chicken stock. Cover and let simmer for 10 to 12 minutes. Remove the chicken and keep warm.

Thicken the sauce with a mixture of butter and flour. In a food processor, purée the sauce and put back in the pan. Incorporate the cream and cheese, mix well.

Serve the chicken breasts on plates covered with sauce. Garnish with apple rings grilled in the oven.

CHICKEN DISHES

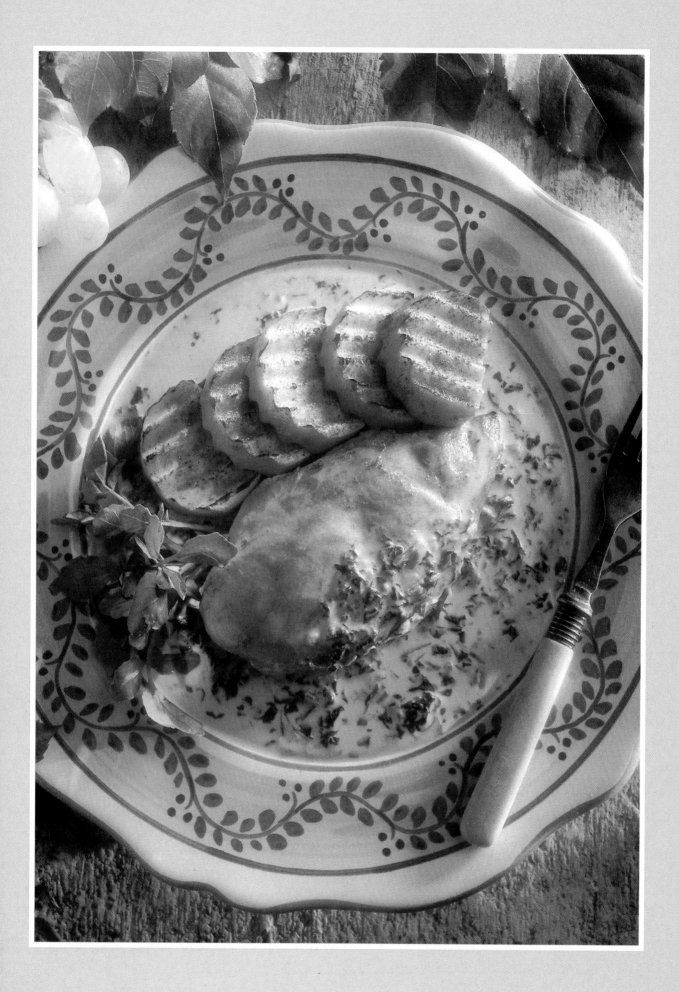

CHICKEN BREASTS WITH BEER

8 SERVINGS

Preparation Time: 15 minutes

Cooking Time: 35 minutes

4	chicken breast halves salt and pepper, to taste
1/4 cup	(50 ml) butter
1 cup	(250 ml) beer
1 cup	(250 ml) chicken stock
1	bay leaf
1	cluster of sorrel, chopped
2 tbsp	(25 ml) all-purpose flour
2 tbsp	(25 ml) butter

Season the chicken and sear with butter in a frying pan over medium heat for 10 minutes. Add the beer, chicken stock, bay leaf and sorrel. Cover and cook over low heat for 35 minutes. In the meantime, mix together the butter and flour. Once the breasts are cooked, remove them from the sauce. Incorporate the butter and flour mixture and stir until the sauce thickens. Adjust the seasoning to taste, and pour the sauce over the breasts and serve.

CHICKEN ROLL-UPS WITH BLUEBERRY SAUCE

4 SERVINGS

Preparation Time: 20 minutes

Cooking Time: 30 minutes

4 oz	(125 g) chopped chicken
2	slices of bacon, cooked and chopped
1	slice of bread, dipped in a little milk
1	egg
2 tbsp	(25 ml) shelled pistachios or chopped walnuts
1	green onion, sliced
1 tbsp	(15 ml) chopped, fresh parsley fresh or dried savory, to taste salt and pepper, to taste
4	6 oz (180 g) chicken breasts
2 tsp	(10 ml) butter
2 tbsp	(25 ml) chopped shallots
1/2 cup	(125 ml) blueberries
1 tbsp	(15 ml) maple or brown sugar
1/2 cup	(125 ml) dry white wine
1/2 tsp	(2 ml) vinegar
1 cup	(250 ml) brown sauce, store bought braised endives

Preheat the oven to 350°F (180°C). In a food processor, mix together the chicken, bacon, bread, egg, pistachios, green onion, parsley and savory; season. Spread the mixture onto the chicken breasts, roll up and secure with butcher's string. Place in a buttered, baking dish and bake for 25 to 30 minutes.

Remove the chicken roll-ups and keep warm. Add the shallots to the pan and lightly brown. Incorporate the blueberries, sugar, white wine, vinegar and brown sauce. Bring to a boil and let simmer over low heat until the sauce thickens.

Slice the chicken roll-ups and serve on plates lined with sauce. Accompany with braised endives.

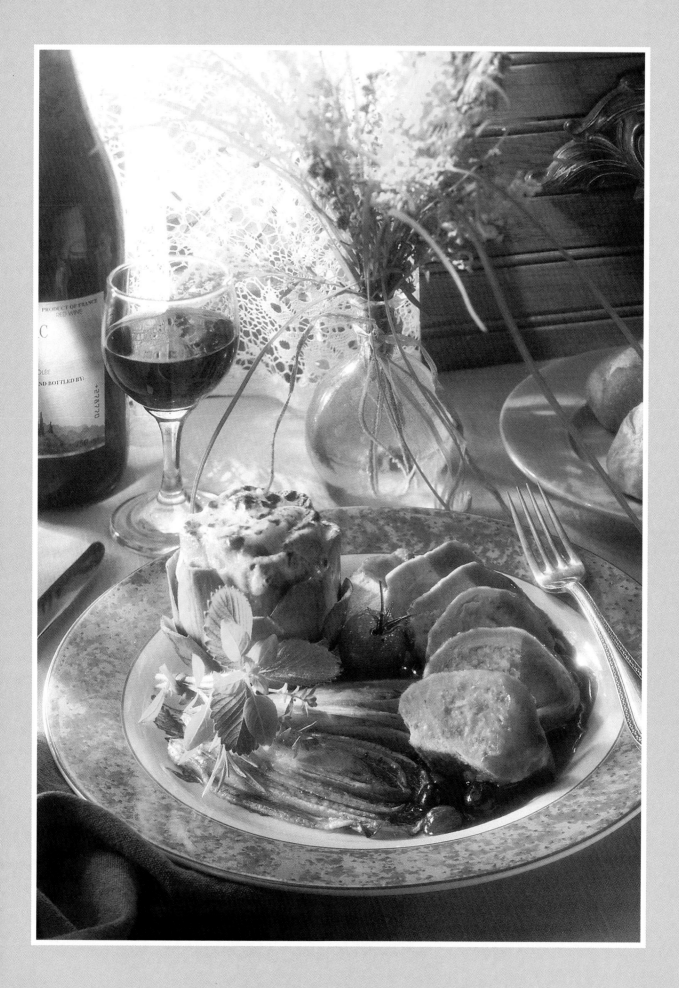

CHICKEN CALZONE

4 SERVINGS

Preparation Time: 20 minutes
Cooking Time: 20 minutes

TOMATO SAUCE

1 tbsp	(15 ml) olive oil
1/2 cup	(125 ml) chopped onions
1 tsp	(5 ml) minced garlic
19 oz	(540 ml) crushed tomatoes, with fine herbs
	salt and pepper, to taste
2 tsp	(10 ml) cornstarch, diluted in a little water

CHICKEN STUFFING

2 tsp	(10 ml) olive oil
12 oz	(375 ml) chicken breasts, cut into cubes
1	green onion, chopped
1/2	zucchini, diced
8	mushrooms, sliced
1/2	green or red pepper
	salt and pepper, to taste

WHOLE WHEAT PIZZA DOUGH

2 tbsp	(25 ml) dry yeast
1 1/2 cups	(375 ml) warm water
4 cups	(1 L) whole wheat flour
1 tsp	(5 ml) salt, sugar, dry oregano, dry thyme and dry basil
2 tbsp	(25 ml) olive oil

CALZONE

1 lb	(500 g) whole wheat pizza dough
1 tsp	(5 ml) olive oil

TOMATO SAUCE

In a pan, heat the oil and sauté the onions. Add the garlic and tomatoes. Season. Let simmer over low heat for 10 minutes. Thicken with cornstarch and keep warm.

CHICKEN STUFFING

In a large pan, heat the olive oil and brown the chicken, green onions, zucchini, mushrooms and the green or red pepper; season. Add 1/3 cup (75 ml) of the tomato sauce and continue cooking for 2 to 3 minutes; let cool.

PIZZA DOUGH

In a bowl, mix together the yeast and the warm water; let set for 5 minutes.

With an electric mixer or a food processor, equipped with a dough hook, mix together 3 cups (750 ml) of flour, salt, sugar, oregano, thyme and basil.

Add the yeast and olive oil to the flour mixture and mix well. Gradually add 1 cup (250 ml) of flour until the dough becomes elastic and not sticky. Place the ball of dough in a lightly oiled bowl and cover with plastic wrap. Let rise for 1 hour.

Knead the dough and divide into four equal balls. Cover with plastic wrap and refrigerate.

CALZONE

Preheat the oven to 400°F (200°C)

Roll out the pizza dough into four 9 in (23 cm) circles. Fill with the stuffing and close in the form of a half moon; brush lightly with olive oil. Place on a lightly oiled cookie sheet and bake for 10 to 12 minutes or until the dough is golden. Serve on plates lined with the tomato sauce and accompany with a green salad.

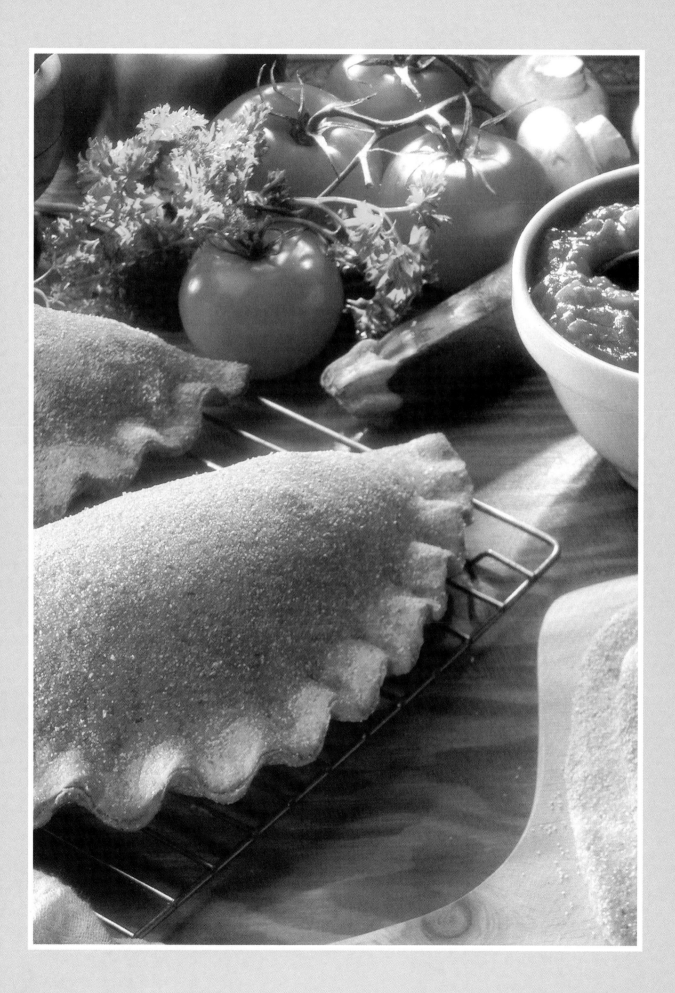

CHICKEN BREASTS WITH POTATOES

4 SERVINGS
Preparation Time: 15 minutes
Cooking Time: 35 minutes

1 tsp	(5 ml) butter
1 tsp	(5 ml) corn oil
1 lb	(500 g) chicken breasts
	salt and pepper, to taste
2	green onions, sliced
3/4 cup	(175 ml) sliced celery
3/4 cup	(175 ml) julienned carrots
1	bay leaf
1	sprig of parsley
1	sprig of thyme
2 cups	(500 ml) chicken stock
1 cup	(250 ml) water
3 cups	(750 ml) sliced potatoes

In a large pan, heat the butter and oil and cook the chicken breasts for 1 to 2 minutes on each side; season. Remove the chicken and set aside.

Add the green onions, celery, carrots and spices; cook for 1 to 2 minutes. Add the mixture of chicken stock and water; set aside.

Preheat the oven to 350°F (180°C). Place the chicken in a casserole dish, surround with the potatoes and the stock from the vegetables. Place in the oven and bake for 25 to 30 minutes or until the potatoes are cooked. Add water during cooking time, as needed.

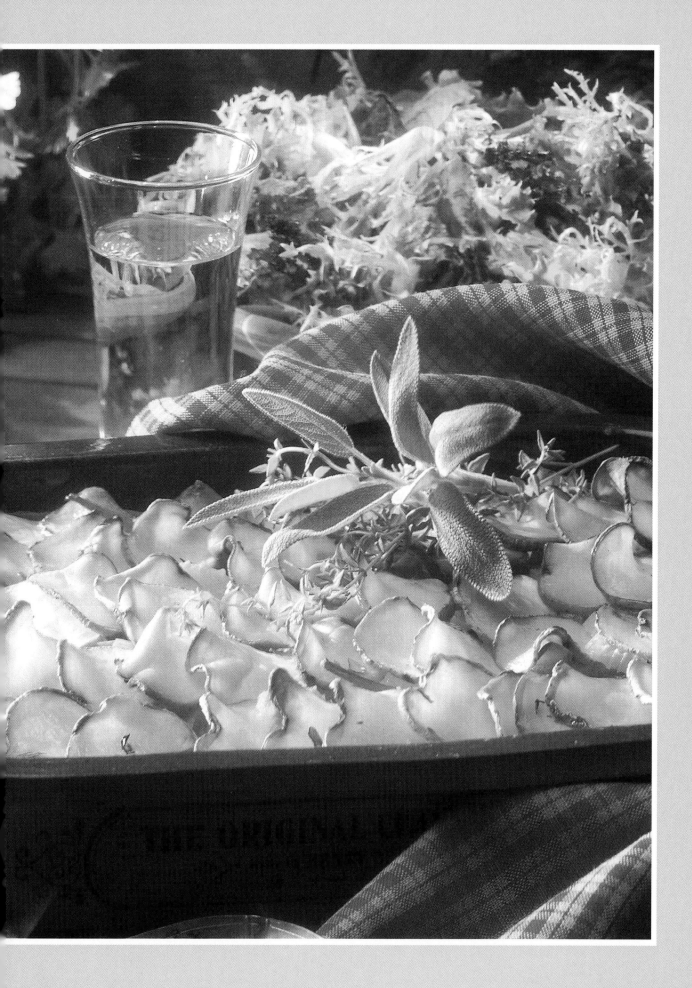

CHICKEN BREASTS WITH ASPARAGUS

4 SERVINGS

Preparation Time: 25 minutes

Cooking Time: 15 minutes

2 tsp	(10 ml) olive oil
1 tsp	(5 ml) butter
1 1/2 lb	(750 g) boneless chicken breasts
	salt and pepper, to taste
2 tbsp	(25 ml) chopped shallots
1/2 lb	(250 g) asparagus,
	blanched and diced
1	bay leaf
1	sprig of thyme
1	sprig of parsley
1 cup	(250 ml) dry white wine or
	chicken stock, skimmed of fat
2 tsp	(10 ml) melted butter
2 tsp	(10 ml) all-purpose flour
1	tomato, seeded and diced
1 tbsp	(15 ml) chopped, fresh chives

Preheat the oven to 350°F (180°C). In a large, ovenproof skillet, heat the oil and butter. Cook the chicken breasts over medium heat, for 2 to 3 minutes on each side. Season and finish cooking in the oven for 10 to 12 minutes, depending on the size of the breasts.

Remove the chicken breasts and keep warm. In a frying pan, combine the shallots, half of the asparagus and the spices; cook for approximately 1 minute. Add the white wine and chicken stock. Let reduce by half and thicken the sauce with a mixture of butter and flour; purée in a food processor.

Line each plate with sauce, the remaining asparagus, diced tomatoes and chives; slice the chicken breast and place on top. Serve.

STUFFED CHICKEN LEGS

4 SERVINGS

Preparation Time: 20 minutes

Cooking Time: 15 to 20 minutes

4	chicken legs, deboned
3/4 cup	(175 ml) instant rice, cooked
1/4 cup	(50 ml) cooked wild rice
1	pinch of thyme
	salt and ground pepper, to taste
1 cup	(250 ml) chicken stock
SAUCE	
3 tbsp	(50 ml) butter
1	shallot, finely chopped
1/2 cup	(125 ml) chopped lettuce
1/4 cup	(50 ml) chopped spinach
1 cup	(250 ml) chicken stock
1/2 cup	(125 ml) dry white wine
1/2 cup	(125 ml) 35% cream
	pepper, to taste
4	sprigs of fresh thyme

In a bowl, mix together the instant rice, wild rice, thyme and pepper. Stuff the interior of the legs with the mixture and close with a toothpick.

Place in a baking dish, add the chicken stock and cook at 400°F (200°C) for 10 to 15 minutes.

SAUCE

Heat 1 tbsp (15 ml) of butter and add the shallots. Add the lettuce, spinach, the chicken stock and the wine. Simmer for 5 minutes.

Add the cream and bring to a boil. In a food processor or by using an electric mixer, reduce to a purée. Add the rest of the butter, season with pepper and keep warm.

Pour the sauce onto the serving plates, place the chicken on top and garnish with a sprig of fresh thyme. Accompany with vegetables of choice.

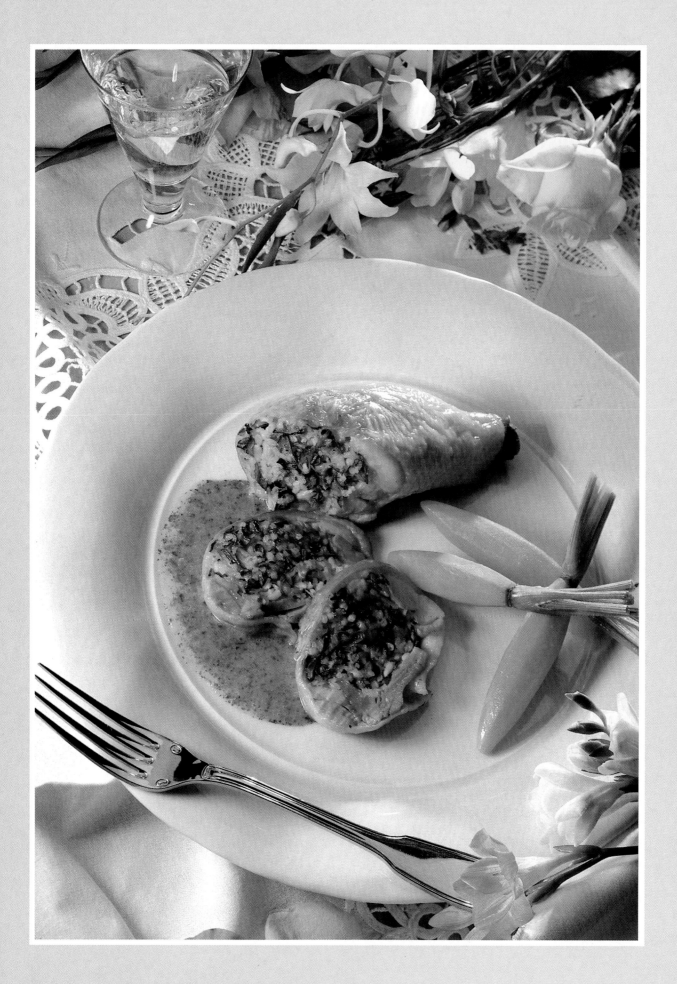

CHICKEN AND POTATOES

4 SERVINGS

Preparation Time: 15 minutes
Cooking Time: 40 minutes

1 tsp	(5 ml) butter
4	chicken breast halves, boneless and skinless
4	potatoes, peeled salt and pepper, to taste
2	green onions, sliced
1 tsp	(15 ml) chopped, fresh parsley
1 cup	(250 ml) 35% cream
1 cup	(250 ml) 15% cream

Preheat the oven to 350°F (180°C). In a pan, heat the butter over medium heat. Add the chicken breasts and cook for 2 minutes on each side.

Place the chicken in a lightly buttered roasting pan and set aside.

On a cutting board, cut the potatoes into very thin rings and place around the chicken breasts. Season and add the green onions, parsley and cream. Bake for 30 to 35 minutes.

CHICKEN BASQUAISE

4 SERVINGS

Preparation Time: 40 minutes
Cooking Time: 1 hour

2 tbsp	(25 ml) olive oil
1	chicken, skinless and cut into 8 pieces salt and pepper, to taste
1 tbsp	(15 ml) paprika
1/2 cup	(125 ml) capiccolo, cut into strips
2	cloves of garlic, minced
2	onions, sliced
2	green peppers cut into strips
2	red peppers cut into strips
1 cup	(250 ml) dry white wine
14 oz	(398 ml) crushed tomatoes, drained
1 tsp	(5 ml) chopped, fresh thyme
1 tsp	(5 ml) chopped, fresh oregano
1	bay leaf

Preheat the oven to 350°F (180°C). In a pan, heat the olive oil. Season the chicken with salt, pepper and paprika; cook until golden. Remove from the pan and set aside.

Add the capiccolo, garlic and onions to the pan; cook for 5 minutes, and add the peppers. Let cook for another 2 minutes.

Add the white wine, tomatoes, thyme, oregano and the bay leaf.

Put the chicken in a casserole dish, cover and bake for 45 minutes. Serve hot, with rice or pasta.

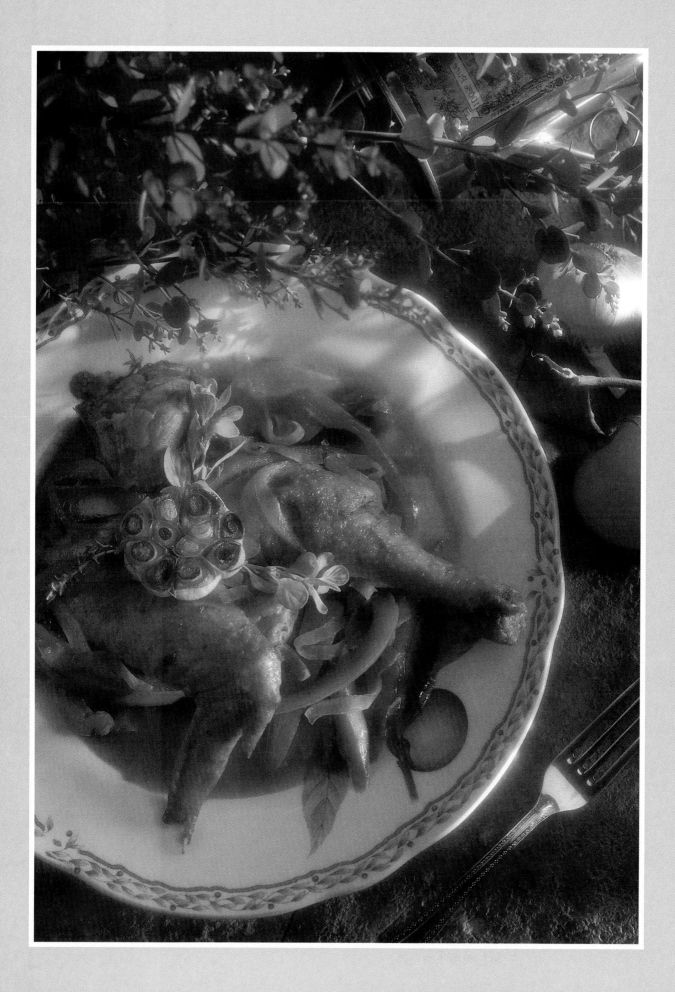

CHICKEN WITH BARLEY AND MUSHROOMS

4 SERVINGS
Preparation Time: 25 minutes
Cooking Time: 1 hour 10 minutes

2 tbsp	(25 ml)	corn oil
1 1/2lb	(750 g)	chicken breasts, cut into 1/2 in (1 cm) cubes
2		onions, sliced
2 cups	(500 ml)	small mushrooms, quartered
1 1/3 cups	(325 ml)	barley
28 oz	(796 ml)	tomatoes
3/4 cup	(175 ml)	chicken stock, skimmed of fat
2 tsp	(10 ml)	chopped, fresh thyme
		salt and pepper, to taste
2 tbsp	(25 ml)	chopped, fresh parsley

In an ovenproof skillet, heat the oil over high heat and cook the chicken until golden. Add the onions and let cook for 5 minutes. Add the mushrooms and cook for another 2 minutes, while stirring.

Add the pearl barley, tomatoes, chicken stock and thyme. Season and mix well.

Cover and bake in the oven at 350°F (180°C) for 1 hour or until the barley is tender and the liquid is completely absorbed.

Garnish with parsley and serve immediately.

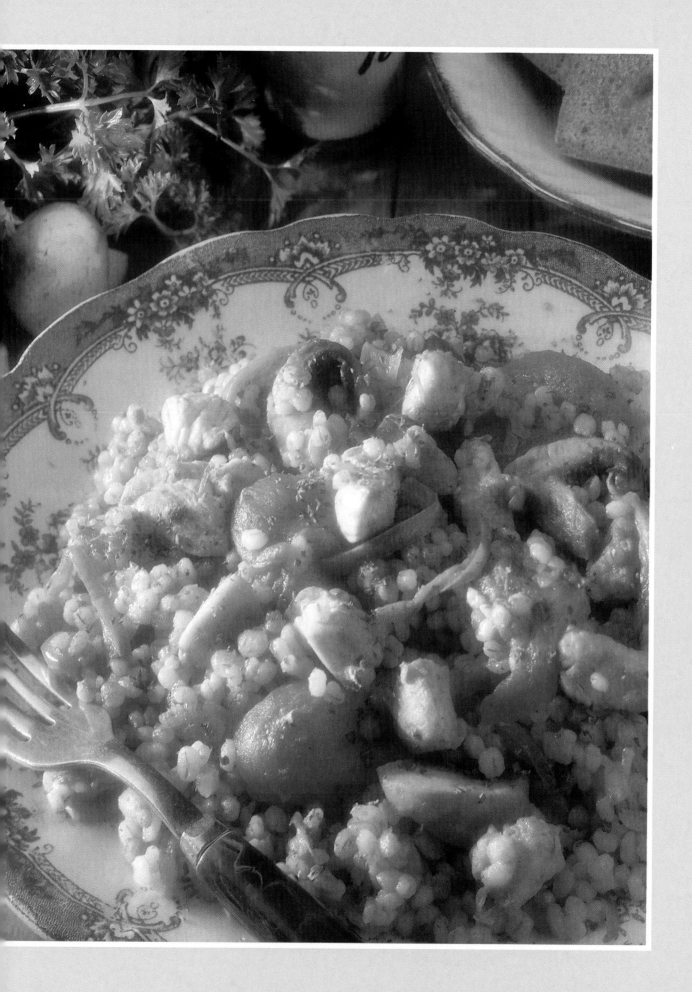

MAPLE CHICKEN BREASTS WITH BEER

4 SERVINGS

Preparation Time: 10 minutes
Cooking Time: 20 minutes

12 oz	(341 ml) beer
1 cup	(125 ml) maple syrup
2 tbsp	(25 ml) tamari sauce
1 tsp	(5 ml) grated, fresh ginger
1/2 tsp	(2 ml) ground, fresh coriander
1 1/2 lb	(750 g) chicken breasts, boneless and skinless
1 tbsp	(15 ml) olive oil
2	slices of bread, crumbled

In a pan, heat the beer, maple syrup, tamari sauce, ginger and coriander. Reduce by half, pour into a large bowl and let cool.

Add the chicken breasts and let marinate in the refrigerator for 24 hours.

Preheat the oven to 350°F (180°C). In a pan, heat the oil and cook the chicken over high heat for 1 minute on each side. Place in a baking dish and bake for 12 to 15 minutes, while basting with the marinade.

Sprinkle with bread crumbs near the end of the cooking time.

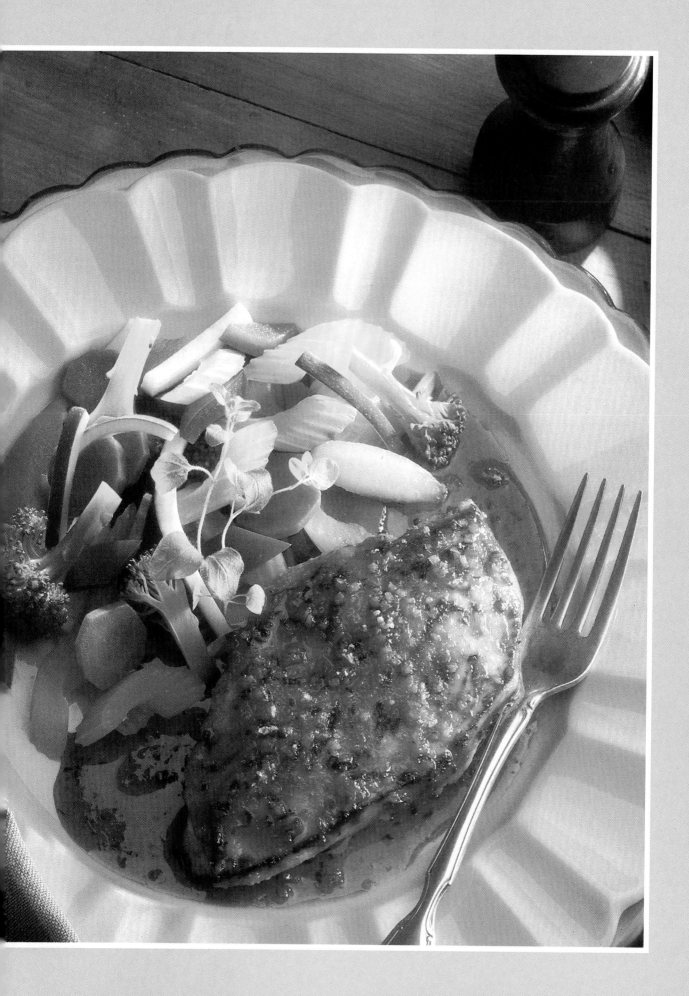

TABLE OF CONTENTS